£16.99

Celebrity Portraits

Celebrity Portraits

PRACTICAL TIPS ON PAINTING PORTRAITS

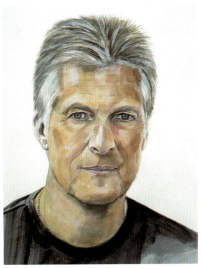

ALAN HYDES

Author's acknowledgements

I would like to thank everyone who is featured in this book for their time and patience. I am deeply indebted to all the celebrities for their fantastic support. In particular, my dear friend Kay Mellor, who took time out to help when she was busy writing TV dramas up against tight deadlines. My grateful thanks, too, to Jilly Cooper, who has been so supportive and helpful, and whose encouragement and enthusiasm have been invaluable.

Thanks, too, to all the people who have commissioned my paintings, watched my TV programmes and attended my exhibitions. Without their support this book would never have happened. Most of all, I want to thank my family for putting up with me as I virtually glued myself to a word processor or locked myself away in my studio to write this book.

First published in 2003 by
Collins, an imprint of
HarperCollins*Publishers*
77-85 Fulham Palace Road
Hammersmith, London W6 8JB

The Collins website address is: www.collins.co.uk

Collins is a registered trademark of HarperCollins Publishers Limited.

07 06 05 04 03
6 5 4 3 2 1

© Alan Hydes, 2003

Alan Hydes asserts the moral right to be identified as the author of this work.

A catalogue record for this book is available from the British Library

Created by: SP Creative Design
Editor: Heather Thomas
Designer: Rolando Ugolini
Photographers: Alan Hydes, Jeremy Phillips

Additional photographs: pages 8 and 9 by kind permission of the National Gallery, London; pages 78, 84 and 123 by kind permission of *Yorkshire Post*/Ross Parry Agency; pages 32 and 64 reproduced courtesy of the *Telegraph & Argus*, Bradford
Framing: The Original Art Shop, Otley, West Yorkshire
Mouldings: ARQADIA, Birmingham

ISBN 0 00 716934 5

Colour reproduction by Colourscan, Singapore
Printed and bound by Bath Colourbooks

Alan Hydes' websites can be visited at www.alanhydes.co.uk and www.alanhydes.com.

Contents

Foreword

I confess that I loathe having my portrait painted. The enforced inactivity when I could be reading a book, or writing my own, or gardening, or doing things in the house or walking my dogs, drives me absolutely crackers. I have to admit therefore that I only agreed to be painted by Alan Hydes because I was writing a novel about the art world and one of my heroes was a very good-looking portrait painter. I thought it would be invaluable for my research to see a truly talented artist at work.

In fact, the experience was a delight. Alan adores his work and thoroughly enjoys the challenge of bringing people to life. He also manages to make the act of portrait painting a real adventure, but one that he takes with huge seriousness.

His background and training as a fine artist mean that he follows the old school of painting which involves pure draughtsmanship. Before any paint touches the canvas he produces loads of drawings as a way of familiarizing himself with the sitter. As he works, he regales one with endless, glorious and sometimes scurrilous anecdotes of other people he has painted. In the period we spent together, he also taught me so much about painting that I had forgotten, or didn't know, which was an enormous help with my book.

Alan also puts a huge amount of himself into his portraits. But he appears so relaxed and is so entertaining as work is in progress that one is amazed at the end to find a picture of great beauty and sensitivity.

When I first saw my finished portrait I almost wept because he had made me so much more attractive and charming than I actually am. I would love to look like that all the time, but it's nice to know that perhaps I do occasionally. The portrait now hangs in our house in Gloucestershire, and everyone seems to love it.

I am sure Alan's book will encourage lots of people to pick up their paint brushes and have a go at portrait painting and that they will find his advice invaluable.

Jilly

Alan Hydes. 2000

I ntroduction

Some experiences you never forget; they live on in your memory as vivid images. I felt this when I saw a portrait of Maria Luisa de Tassis by Van Dyck, painted in 1629. She gazed out of the canvas, making eye contact with me, and it was as if I knew what she would be like in real life. It was an uncanny, moving experience to stand in front of that painting and to feel the living woman's presence.

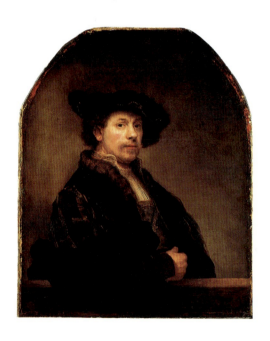

⊕ Rembrandt
Self Portrait at the Age of 34
Oils
102 x 80 cm (41 x 32 in)
This wonderful painting depicts Rembrandt as a wealthy, successful artist. It demonstrates his remarkable ability to bring a portrait to life by using oils in a masterful way. His use of light enhances the image, creating atmosphere.

© National Gallery, London

Representing character

A good portrait is more than just a painting; it brings you an awareness of the sitter and a feeling for their character. Seeing portraits painted hundreds of years ago always fills me with awe. It makes me aware of my own mortality and I feel like a child looking into the vast, star-spangled night sky, feeling very small and insignificant. Portrait painting is more than just depicting a person on canvas. It requires the artist to put their own inherent visual perception into the work. You have to decide what you feel your sitter is really like.

We are all different and that individuality of character and temperament should be evident in a portrait. When the ancient Egyptians painted portraits more than 4,500 years ago, they simply showed a person's features with no real sense of whom they were depicting. Throughout the following centuries, artists focused increasingly on their subjects' characters. This eventually inspired artists such as Picasso to produce portraits of their sitters incorporating views of the person's face from different angles, emphasizing their features, and painting in colours that best expressed their emotions. Picasso's portraits became real journeys of experimentation in expression, and the joy of using colour and form transformed a portrait into a great work of art.

In the past, some artists raised the art of portraiture to the height of perfection, giving us not only a sociological record of people throughout history but also an insight into these living people simply by applying paint to canvas. We all have our favourite portrait painters and my preferences are very varied; I appreciate different artists for different reasons. Some paint wonderful portraits with little detail – just a marvellous feel for paint and colour. Van Gogh, for example, used pigment in a

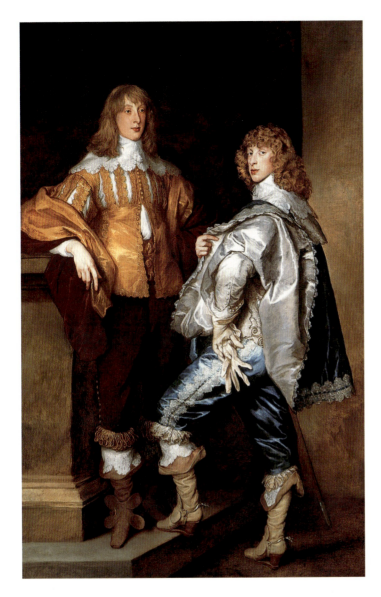

Anthony Van Dyck
Lord John Stuart and his Brother, Lord Bernard Stuart
Oils
242.5 x 148.5 cm
(97 x 59 in)
The portrait of the two young Stuart brothers, painted in 1639, not only depicts the faces very realistically but it also describes their fine clothing in such a way that you feel that you could reach out and touch the fabrics.

© National Gallery, London

very painterly way, applying it with great feeling and energy. Consequently, his portraits often distort the sitter's features. Although his palette incorporated colours that one would not normally associate with skin tones, the portraits work and have a great presence. Paul Gauguin, a contemporary of Van Gogh, simplified his sitters' faces and frequently used black lines to emphasize their features. His portraits of Tahitian girls have wonderful mood and atmosphere.

One of the most famous portraits is the *Mona Lisa* by Leonardo da Vinci. It is most people's idea of what a great portrait should be. He captured her celebrated enigmatic smile which appears different each time you view it. Portraits like this have an almost magical quality which is unforgettable.

The aim of this book

Portrait painting is extremely personal; a good portrait is a combination of the sitter and the painter and represents the sitter as seen through the artist's eyes. Some painters produce figurative, almost photographic images whereas others paint an impression, using the sitter as their inspiration.

In this book, there is advice and practical tips on how to set about painting a portrait. My work is personal to me, and my method of working has developed over many years. I can pass on help and advice, but it is up to you to develop your own individual style and ways of painting once you have the confidence to use different kinds of painting materials.

Drawing is the foundation

My own experience has been based on keen observation and draughtsmanship. I place great importance on drawing as a foundation for my work. Painting is a visual language; you are saying something pictorially that people can read and understand, so you have to learn the language before you make a visual statement. The basic form of this

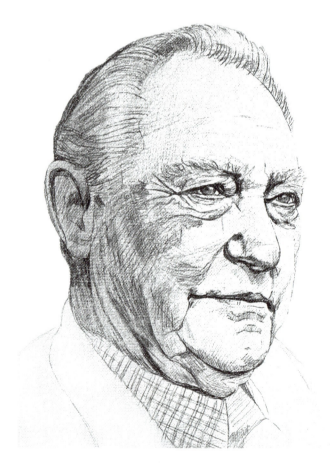

▶ The drawing I did as a study for my portrait of actor and film star Richard Todd was produced as a structure on which to build the final oil portrait. It had lots of detail in the eyes to provide me with maximum information.

language is drawing. If you can draw well, in perspective and with a good understanding of form and mass, you can build on that skill and use it as the foundation to your painting.

All my portraits begin with a drawing. I look at my sitters from all sides and draw them from different angles, too, to understand the structure of their faces. I say things in my drawings about how the sitter looks so I can make a better visual statement when I start working on the portrait.

To learn to draw well, you need lots of practice! I strongly recommend going to an art class, where an experienced artist can help you to develop your skills. Drawing a life model is a valuable and important way to train your eye – if you get anything wrong, it shows immediately. Not only do you draw a person's face but also the whole body. This helps when you are painting full-length portraits as it gives you a far greater awareness of how the human form is structured.

Throughout this book, you will find many examples of how to build up a portrait from the most basic of drawings to the final painting ready for framing. It is my intention to provide an awareness of the different methods and techniques that you can apply in your own personal way.

Bringing out character

I am very privileged to have painted some of the most well-known faces in the UK. Some have been a joy to paint, especially those with 'lived-in' faces, such as Lord Healey, Dame Thora Hird, Ricky Tomlinson and Lord Harewood. Their life experiences are etched into their features, making the activity of committing their personality to canvas that much easier because there are many reference points.

There is little point in producing a purely photographic likeness. A portrait should do more than just represent what a person looks like. It should show the sitter's personality and character, bringing the image to life.

There's no substitute for experience in the art of portraiture: in drawing, colour awareness, painting techniques and very keenly developed observation. You should also be aware of what has gone before in the history of portrait painting. Visit some galleries and come face to face with the work of the great masters – Titian, Raphael, Van Dyck, Picasso, Matisse, Leonardo da Vinci and the rest. You will learn so much by looking at how they used paint and lit their subjects.

This book can give you a helping hand on your journey through portrait painting, but it can only take you so far. I hope that your painting brings you satisfaction and enjoyment.

Ⓐ Ricky Tomlinson has a wonderful face to paint as it is so 'lived in'. As a character actor, his face is his fortune, and we can all see why! You could hardly ever hope to find a more interesting face to paint.

M aterials

When it comes to deciding which materials to use for painting your portraits, the list is vast, and it all depends upon your own personal preference. I love working in oils, but I also paint in watercolours frequently, and acrylics are terrific if I want the work to dry relatively quickly. Here are some basic guidelines to the essential drawing and painting materials that you will need.

Drawing and sketching

To get started, you need pencils, a pencil sharpener, erasers, drawing paper and a drawing board. You could work directly on to a pad of drawing paper, but even the firmest pads are slightly flexible and I for one need a firm surface to draw on most of the time. Pads are convenient, however, especially when you don't want to drag a heavy board around with you. I always use a variety of drawing pencils from HB to 6B, as these grades provide the range of line and tone which are needed for virtually any portrait. Buy the best pencils you can afford, as a good pencil definitely makes drawing easier. But, above all, remember that your pencils need to be sharp to make an accurate visual statement, so invest in a good pencil sharpener, too. I use an electric pencil sharpener for convenience and quality.

You need an eraser that will not mark your paper surface. Kneaded putty erasers are superb at mopping up the carbon and treating the paper gently. These erasers can also be shaped into a point so you can draw in reverse with them. I often lift out quite fine highlights by working on a tonal area and taking away the tone in small areas with a putty eraser to reveal the white paper underneath.

The big decision is which paper to use. I use a range of drawing papers, but if I know that I might want to apply a watercolour wash later on, I opt for a good heavy paper of, say, 638 gsm (300 lb). Heavy paper does not wrinkle when it gets flooded with water, so there's no need to stretch it. If you want to work on a fine line drawing, however, choose a good cartridge paper with a fine surface. Of course, you can select a coloured pastel paper if you want to apply white to bring out the highlights.

Watercolours

I use these for preparatory studies and portraits. Artists' quality pigments are the finest, providing good overlays of colour in a finished painting and a wonderful range of colours for creating accurate skin tones, especially children with soft peach-like skin. Students' quality paints are cheaper and perfectly acceptable for preliminary studies.

When choosing watercolours for portrait work, select a range of colours that you can also use for clothing and backgrounds. The ones I use are listed in the box (right).

Other mediums I use with watercolours are art masking fluid and watercolour impasto gel. If you want to pick out colours strongly, work some designer's gouache into the watercolour. It has great opacity and tinting strength and can add an extra touch of vibrancy to your portraits.

I never stretch watercolour paper and prefer to work on a heavy paper which is almost like a board – it will take large amounts of water without going out of shape. Thinner papers need stretching to prevent the moisture creating wells for the paint to run into. I also work on watercolour pads. It is up to you whether or not to use a paper with a strongly textured surface, but I favour a rough texture because it takes the paint well and gives a washy feel to the finished studies.

I use sable brushes because they have many distinct advantages. They hold moisture well and, once charged with paint, they are capable of distributing a large volume of colour. They also form a good, sharp point for detailed work. However, sable brushes are quite expensive and some good synthetic alternatives are now available.

Colours

Rose Madder	Yellow Ochre
Naples Yellow	Payne's Grey
Warm Orange	Warm Sepia
Aureolin	Vandyke Brown
Permanent Rose	Raw Umber
Burnt Sienna	Chinese White
Transparent Red Brown	Titanium White
Raw Sienna	

◉ A good range of materials will help you to produce effective watercolour paintings.

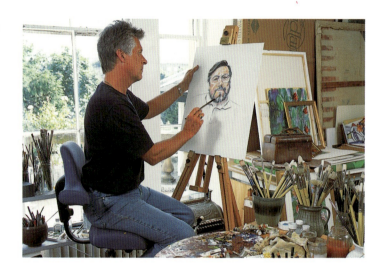

⊙ The author at work in his studio. Natural light creates good painting conditions. However, full sunlight is not advisable as it is too harsh.

Colours

Flesh Tint	Rich Transparent Red
Golden Yellow	Payne's Grey
Golden Ochre	Middle Grey
Buff Titanium	Ivory Black
Raw Sienna	Titanium White
Yellow Ochre	Zinc White
Permanent Rose	

Acrylics

These are easy to use, dry quickly and the colours are very permanent. You can use them with either a palette knife or brush and they perform just like oils if you keep them damp. Oils take a long time to dry before you can apply glazes but, with acrylics, glazing can take place within minutes. Another advantage is that you mix acrylics with water rather than turpentine or linseed oil – so they are virtually odourless.

Acrylic paints are also very lightfast with richly pigmented colours. I tend to use the colours featured in the box (left), but use whatever suits you. To keep the paints moist, buy a 'Stay Wet Palette'. This is a clear-lidded plastic tray which contains 'reservoir' paper for retaining the moisture. You will also need some acrylic mediums to mix with your colours. Do not use sable brushes when painting with acrylics. It is better to use the specialist synthetic brushes which are designated specially for this medium. Selecting the right brushes is important, and they need to feel the right weight and balance when you hold them. So when buying brushes, whether they are for painting in acrylics, watercolour or oils, try holding them in the way you paint before you purchase. You will know instinctively if they feel right for you. There is a wide range of brushes for different jobs and which ones you use depends on your painting style.

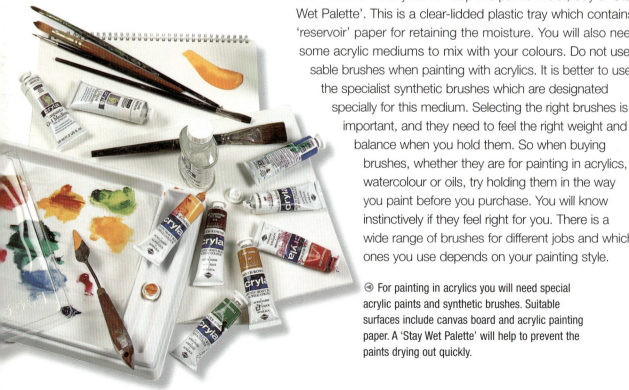

⊙ For painting in acrylics you will need special acrylic paints and synthetic brushes. Suitable surfaces include canvas board and acrylic painting paper. A 'Stay Wet Palette' will help to prevent the paints drying out quickly.

Oils

This is my favourite medium for painting portraits because it provides me with the depth of colour I need, and it is slow to dry, giving me time to push the paint around to develop the portrait. I even like the smell of oil paints, believe it or not!

Always buy artists' quality oil paint if you can afford it. Some colours are expensive, but they are worth it in the long run because they mix beautifully without getting muddy. Some cheaper colours do not mix as well as the high-quality materials. Selecting the right colours for portraits depends on your personal choice, and the ones I use more than any others are listed in the box (right).

I mix my colours using distilled English turpentine, purified linseed oil and purified poppy oil (for lighter colours). The canvas must be well primed with a good gesso primer. I paint onto stretched canvas or canvas board, but you can use all sorts of surfaces, including wood and oiled paper. You can buy canvas boards and ready-stretched canvases from most art shops, or you can buy canvas on a roll and stretch your own onto a wooden 'stretcher'.

I use a combination of hog's hair and sable brushes. Hog's hair brushes are good for underpainting, developing painterly textures and modelling the paint to describe form. Sables are perfect for glazes and fine detail; the flat-ended brushes are great for adding vitality to the final stages of the painting.

Colours

Naples Yellow	Transparent Brown
Flesh Tint	Vandyke Brown
Transparent Gold	Sepia
Ochre	Brown Madder
Italian Pink	Payne's Grey
Aureolin	Raw Umber
Cadmium Red	Lamp Black
Cobalt Violet	Titanium White
Rose Madder	Flake White
Yellow Ochre	

⊙ A selection of the materials that I use for oil painting, including artists' oil paints, a palette, a painting rag, different-sized brushes, palette knife, linseed oil, English turpentine and canvases. Stand your brushes upright in a pot to prevent the delicate tips becoming damaged.

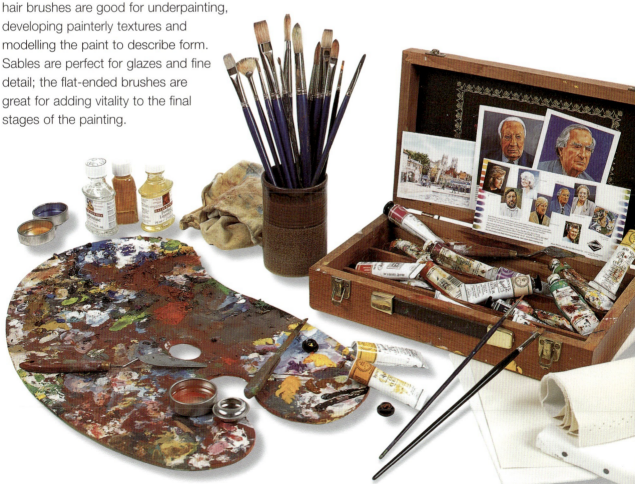

Methods and techniques

I use a variety of materials and techniques, but you must find out what suits you best by experimenting with different methods. When I was at art college, I used this period in my artistic development to explore a wide range of methods and techniques which I applied to my portrait work later on. There is no correct way to use materials but there are basic rules that apply to methods and techniques.

Drawing

Drawing is the foundation for your work. It provides you with a means to explore your subject matter and describe what you see, so I cannot over-emphasize the importance of learning how to draw well.

Line drawing

Using line to describe form is very necessary. Line can provide weight as well as structure if you use it well. Simply by modulating a line you can give it qualities that convey different messages to the brain. By 'modulating the line' I mean changing the tension and weight of any line you draw.

◉ If there is no suggestion of form other than a circle, by 'modulating the line' and putting more pressure on the pencil as you reach the bottom of the circle you produce this. The effect on the eye is that the circle suddenly looks heavy at the bottom, suggesting that it is a ball with some substance.

◉ Even if I draw a nose, I can give it weight. Equally, if you want a line to move towards the viewer you can apply a similar technique.

◉ Using a line to create tension and form can be effective when drawing portraits. A line that is sharp and thin conveys tension, implying tightness. Applied to a head, it gives it more form.

Tone

When you are working on any drawing, make full use of the range of effects you can create. Soft-leaded pencils are great for tonal application; a 5B or 6B pencil will give you a wide latitude of tonal effects.

Charcoal is terrific for tonal effects, too. You can, of course, use lots of other drawing materials to create these effects. Try watercolour washes and water-based pencils.

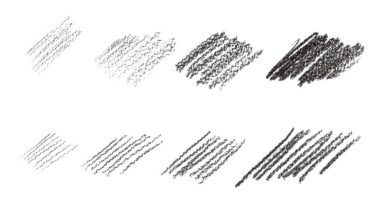

◀ I used a 5B pencil to produce these shaded areas by placing more weight on the pencil as I created darker tonality. It is all a matter of practice when using pencils.

▼ Willow charcoal has been smudged here to create a soft effect, providing form.

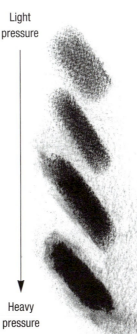

Light pressure

Heavy pressure

◀ Charcoal is very versatile and easy to use. It provides a wonderfully soft feel to tonal areas and can be modulated by putting more pressure on the charcoal as you draw, or by smudging the drawn areas and spreading the tonal areas using the end of your finger.

⊕ You can use watercolours wet on wet and simply allow the colours to blend and merge to create skin tones. This technique is good when you want to create a loose underpainting in a large portrait, or you can simply keep the whole painting wet until you are happy with the result.

⊕ Watercolours are traditionally used like sheets of coloured glass, laying one over the other. Learning how to create different colours by overlapping them comes from practice. It works best if the first colour is completely dry before the next transparent layer is applied.

▷ Allowing the colour to spread and gradate naturally is an effective way of describing form. Wet the whole area first and drift in the colour, allowing it to spread and thin.

Painting in watercolours

I use watercolours to get gentle, soft effects in skin tones. Watercolour is particularly effective when I'm painting portraits of children with soft, peachy skin. I also use watercolour washes when producing important preparatory drawings to provide an indication of the skin tones and give me an opportunity to experiment with the effects of light and shade on the features of the sitter.

I paint my watercolour washes on heavyweight rough surface papers. These allow the watercolour to develop a nice texture which is fluid and attractive. I always use watercolours from tubes, as they are easier to work with. I start off by slightly dampening the paper with a small fine sponge to create soft edges to the colours I apply. I then apply the watercolour quite thinly to the paper surface, placing in the main areas of tone. I like to work quickly with soft sable brushes, keeping the surface slightly wet until I have placed all the main tones where I want them to be. I then let the paint dry for half an hour or so.

When the main underpainting is dry, I apply the soft, gentle skin colours over the top. This way the paint is applied almost like laying one layer of coloured glass over another. So the paint does not mix on the surface of the paper – it simply places one colour over another, thereby stopping the paint becoming muddy and dull. A vibrancy is achieved by allowing the white of the watercolour paper to show through.

It is up to you how you use watercolours, but remember that it is very difficult to lift colour once it has dried. They are great to use if you feel confident and decisive and don't want to go back over your work; otherwise, try acrylics.

Painting in acrylics

I tend to use acrylics when I need a painting to dry quickly and I want an effect that is stronger and brighter than a watercolour. You can make acrylics look like oils by using the pigment thickly, and you can add different mediums to the paint to thicken it or even produce a metallic shimmer!

The paint can be applied with a brush or a palette knife. I map out the face first with a size 2 synthetic bush with a thinned Payne's Grey and let the lines dry. Then I set to work, mixing skin tones from a wide range of colours. If using a palette knife, make the outline brush drawing quite large to get expression and movement into the strokes. The paint is applied heavily; there's no need for the finer detail.

You can use acrylics almost like oils. Working with brushes, lay down an underpainting, introducing thin layers of colour as glazes over the top. Acrylics are less opaque than oils so if you water them down too much, the surface of the dry pigment will resist it, and the thinner, more watery colour applied over the top will break up unless you use an acrylic medium with it. Acrylics often need several layers to make them completely opaque. You can introduce detail with a fine brush, painting in single hairs on the head, eye lashes and tiny reflections of light in the eyes, just like oil paint.

◉ Overglazing acrylics is a technique I like to use, rather than simply mixing the correct colour in the first place, as it gives the painting more vitality. I tend to exaggerate the skin tones slightly initially and then lay over a lighter glaze to take the colour down, creating an interesting and descriptive texture. Quite often there is no need to thin the paint; it usually works straight from the tube.

◉ Acrylics are quite buttery in texture and if you lay one colour over another without thinning the paint in any way you get the initial colour showing through. It is a quick way to underpaint and then glaze over within minutes.

◉ I really enjoy working with a palette knife as it creates a wonderfully dynamic effect. I use a large knife to begin with, and a smaller one where I need some detail. You can sharpen things up with a brush, but it is best if you simply allow the palette knife to create that energy and vitality.

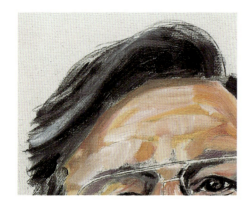

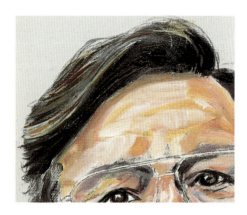

Painting in oils

These are very versatile and are easy to apply with either a palette knife or a brush. If you make a mistake, the error can be wiped away whilst the paint is wet or painted over if it has dried. Oils are foolproof materials but very permanent in terms of colour fastness.

Distilled English turpentine helps the paint dry reasonably fast whereas mixing oil paint with linseed oil will slow down the drying process. If you want to work wet on wet, you need to give yourself the slowest possible drying time. By wet on wet, I mean working on an oil painting with the paint wet at all stages to give the painting that immediate fluid look.

Working with oils in a more conventional way means that you let the paint dry before overworking in glazes or creating detailed sections. I often paint individual hairs on the heads of my portraits but this would be impossible unless the underpainting was completely dry, as the fine sable brush strokes merge into the paint if the underpainting is wet.

⊛ Painting wet on dry is the technique I usually employ when painting hair. In this illustration, I let the dark Payne's Grey dry before painting strands of hair over the top, using a range of browns and Naples Yellow.

⊛ When I painted Ricky's beard I wanted the effect to be a little softer than the one I created painting his hair. So I painted the beard hairs on while the flesh colours were still wet. Using this wet on wet technique allowed the lines to smudge slightly and be less harsh.

Glazing

Overglazing can almost be like applying make-up to a bare face. If you have described the face well in the first place, using a wide range of colours, the glazing can correct an over-harsh tone or a weak tint. When glazing, I tend to work over several days, allowing the thin, translucent colours to dry before adjusting them. I like to revisit the portrait over a few weeks before I actually feel it is complete. If you are painting a full-length portrait, you can spend time working on other elements while the face is drying.

Glazing is perhaps most effective if you apply the glazes very gently. The underpainting should provide you with a good structural feel to the portrait, emphasizing the angles of the face and providing the basic skin tones with quite thick paint. I always like to see the brush strokes describing the planes of the face giving the portrait weight and form. Then once I am happy with the structural painting the glazes provide the more subtle tones and hues, giving the painting its final warmth of colour and bringing it to life.

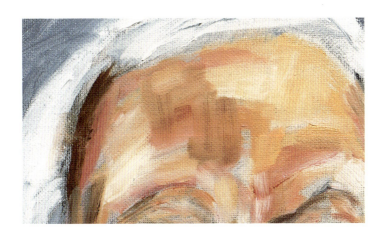

◁ When painting Sir Edward Heath I produced an underpainting which was fairly close to the skin tones I wanted to see in the final portrait. When I applied Naples Yellow over the top of the underpainting it toned the colour down very gently to create the effect I wanted.

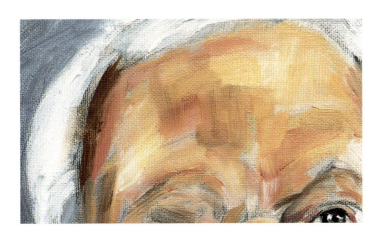

Looking at faces

It is quite remarkable how in a world of millions of people, no two faces are ever alike. Even identical twins have something about their features that makes each one slightly different. So it is not surprising that facial features can vary enormously. There are racial characteristics that we all recognize but even if a particular race tends to have very pronounced features, faces are never absolutely the same.

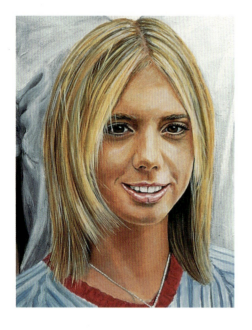

⊕ This detail from the large portrait I painted of the O'Leary family captures the essence of Ciara. She looks young, vibrant and beautiful and the image conveys her youthful optimism.

Capturing the sitter's essence

When you are drawing a sitter, take great care to represent their features accurately. Over-emphasize some features if you think it helps to build character into the portrait, but take care to ensure that any visual emphasis still gives the observer a true sense of what your sitter really looks like.

Portraits, by artists such as Picasso, Matisse and Van Gogh, are certainly not a photographically realistic depiction of their sitters. Yet if you saw one of their paintings and later encountered the sitter you would probably recognize them. In each case, the artist has captured the essence of the sitter on the canvas by keen observation of the person's features even if they are not to scale. Picasso would even move around his sitter and paint from different angles. Yet the features he put together in a cubist fashion still totally described the model.

So what are we looking for in a person's features? The answer is simple: we need to assimilate in our mind's eye the things that make that face interesting. Could it be the sitter's big wide nose or full lips, the expressive eyes or the large eyebrows? I am sure that we have all seen cartoonists at work, poking fun at their sitters by making someone with a large nose, for example, look as if they have an enormous vegetable-shaped appendage stuck to their face. Yet the sketch ends up looking just like the person they are drawing.

This is an extreme example of using physical features to add character to a portrait and, although I do not recommend it, it does allow you to see how features can be distorted and still retain the essence of the sitter. You do have plenty of latitude before you lose sight of the

person you are painting. You can produce a painting which bears a great resemblance to your sitter if you focus on their main characteristics.

Enhancing the sitter's features

Whenever I take artistic licence it is usually to enhance the image of the sitter. I will slightly tighten a jaw-line, remove a few wrinkles perhaps and maybe enlarge the eyes, but I do this quite often as lines and baggy flesh may detract from the vibrancy of the sitter's personality. I don't think that I have ever made anyone look really old and tired whatever their age. I show the age of the sitter in the features but I don't dwell on any unsightly elements. What I am trying to capture is the person's character.

My best advice is to measure your sitter's facial features accurately, and then, if you feel it is necessary, exaggerate slightly the things that you feel say a lot about the person. I certainly went to town on the features of Ricky Tomlinson (see page 33), Dame Thora Hird (see page 57) and Richard Todd (see page 81). They were all people with really interesting facial features – a joy to paint and a dream for any portrait artist.

◉ I produced this pencil drawing of Robert Palmer's head to show him how I wanted his image to appear on a CD (see page 105). I used heavy pencil on a textured paper, almost like canvas, as it broke the tonal areas down well. The angle gave Robert a strong, tight jaw-line.

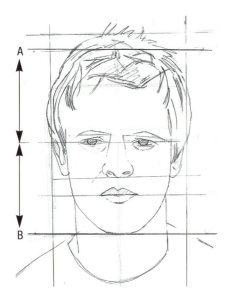

⊕ When measuring the head, remember that there are a some things that can give you a guide to find out if your measuring is accurate. In this diagram you can see that the eyes are halfway between A and B. Most people imagine that the eyes sit two-thirds of the way up the face.

Drawing and measuring

The more you draw your sitter, the more you will understand their individual physiognomy. Every face is different and, no matter how many times you draw it, it will always be a challenge. However, drawing is invaluable and if you get the structure and the framework wrong in the drawing stages you will almost certainly fail to produce a portrait which has real presence and character.

I enjoy working directly from my sitters using the age-old method of measuring with a pencil by eye. It is a very simple but foolproof way of getting the proportions right. Many people rely on what they think they see without backing it up by checking out the measurements. It is so important that you discipline your visual perception and train your eyes to be an accurate judge of distances. The more you measure, the better you will become at assessing the size and shape of what is in front of you. I check measurements regularly, but after years of training my mind to assess distances well I can now draw more fluently without having to measure every distance.

Measuring technique

Firstly, make sure that you are close enough to the sitter to be able to see clearly all elements of their face (and body if it is a full-length portrait). Then position yourself so that your canvas or drawing board does not obscure your vision.

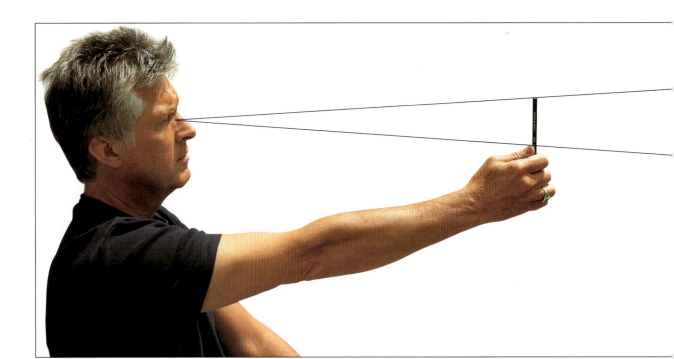

Making sure you keep your body in the same position, stretch out your drawing arm fully and hold your pencil upright so your thumb can slide effortlessly up and down the pencil. With your arm fully extended, close one eye and align the end of the pencil with the top of the sitter's head. Keep your pencil in that position, moving your thumb down the shaft of the pencil until it is level with the sitter's chin.

Then, keeping your thumb firmly in position, apply that measurement to the paper. Multiply that measurement on the paper until you have a size that suits your requirements. Make a little mark for the top of the head and one for the line of the chin. You now have an exact measurement of the height of the sitter's head.

Now do exactly the same thing again: measure the height of the head using the pencil and hold that measurement on the pencil, but this time turn your pencil so it is horizontal and see how the height of the head compares to the width. Multiply that measurement the same number of times on your drawing. You can make a rough visual statement about the head shape, knowing your measurements are accurate.

Each time you want to measure the features, use the same method, but remember to keep yourself and your sitter the same distance away from each other. If you step, or even lean, forwards when you are doing the measuring, you will, of course, end up with inaccurate measurements.

⊛ Not only does the artist have to keep in the same position when measuring, but the sitter must remain still too. So do not let your sitter move backwards and forwards as this will adversely affect the measuring process.

Developing a sketch

Once the features are plotted out and sketched in I then consider the tonal elements and I roughly shade in areas of the face to indicate where the light falls across the features. This begins to give the drawing a more three-dimensional quality. I usually use a 3B pencil to add tonality, but much depends on the surface I am working on. Canvas takes pencil well if it is well primed, but charcoal is also effective and it can be pushed around better on a textured surface. Much depends on how much detail you want to see at this stage. Charcoal is good for getting proportions and shapes well defined, but if you are concentrating on more detail, pencil is the only real option.

Before I begin a portrait, I draw the sitter from various angles: full face, right and left sides. It is amazing how much you learn about your sitter's features by drawing them from a range of viewpoints. Most people's faces are quite different when viewed from the other side. If you took a photograph of a human face, cut it in half down the middle and then fixed one side of the face to a mirror image of the same side you would create a face with a totally different persona.

⏷ I produced several sketches of actress Liz Dawn from different angles. They were drawn very quickly and the colour I used was minimal, just enough to suggest her skin tones and eye colour.

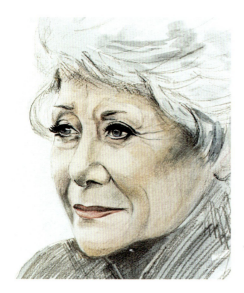

⏵ This very quick colour sketch of Liz Dawn was produced using a pencil and fine watercolour washes. I concentrated my efforts on her eyes in an attempt to bring out her real character.

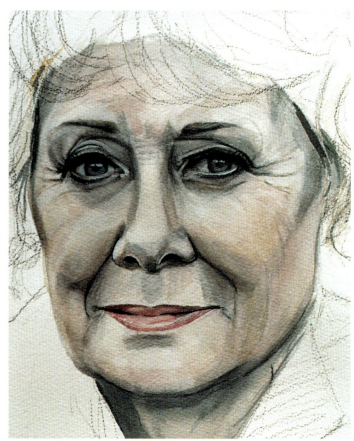

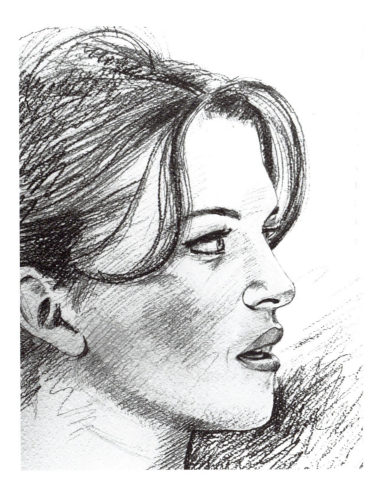

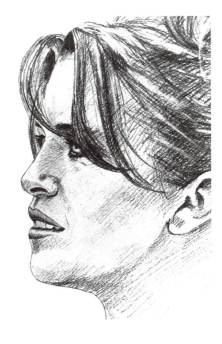

The actress Tina Hobley has very good bone structure and lovely eyes. I produced these quick sketches just to familiarize myself with her features.

This colour sketch of Tina played upon the shape of her eyes.

Choosing the right angle

After spending some time sketching my sitter, I then decide which angle best represents the person in front of me. For example, a woman with lots of vitality and energy in her personality would be posed differently from, say, a senior politician. I always try to bring out the character of the individual sitter by all means possible, and the pose is an important part of that process. A vibrant young woman, for instance, might be posed looking relaxed and leaning across the back of a chair whereas a politician would better suit a more formal pose.

If you are photographing your sitter, take lots of photos from a range of different angles and distances away from the subject. Give yourself the widest possible choice of potential poses. You can then select and blow up certain images and draw from them before making any decision on the final composition. You might end up doing just a head-and-shoulders portrait, or the person commissioning the work might prefer a full-length portrait – so make sure that you give yourself every option.

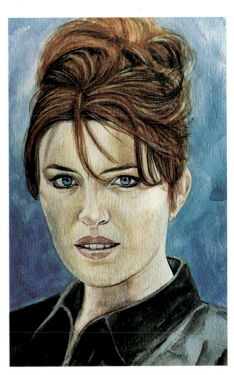

Ricky Tomlinson

When I found out that I would be painting Ricky Tomlinson for my TV series, I was over the moon! Not only is he one of my favourite comedy actors but he also has the most fascinating face to paint. It is a face full of character and experience which life has modelled into forms that are a pure delight for any portrait painter. He is a real character – a man of principle who has experienced the rough along with the smooth. However, under the brash exterior I also found a man of great sensitivities, a person who has great compassion for the underprivileged and someone who loves art. Ricky showed me some of his paintings when we first met at his home in Liverpool, enthusing about how he liked to experiment with different kinds of painting media.

Born in Blackpool in 1939, Ricky Tomlinson played banjo in Liverpool's clubs before being involved in the 1972 builders' strike. A leading film and TV actor, he has appeared in the highly successful *Boys from the Blackstuff* and *The Royle Family*. But in spite of his fame and wealth he never forgets his roots.

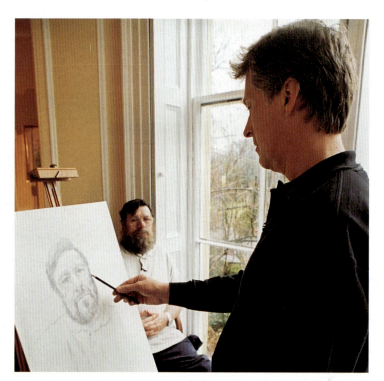

However, when he turned up at my house for a sitting he looked nothing like the familiar Ricky Tomlinson. He was clean shaven, apart from a small moustache. His familiar beard had been shaved off for his latest role but I wanted his portrait to show him with a beard. I was rather taken aback, but he instantly allayed my fears by telling me he had brought along a false beard specially for the sitting! Relief was obviously written all over my face as he burst out laughing.

◬ I began by measuring out the proportions of Ricky's face (see page 24) and then very lightly sketched in his features.

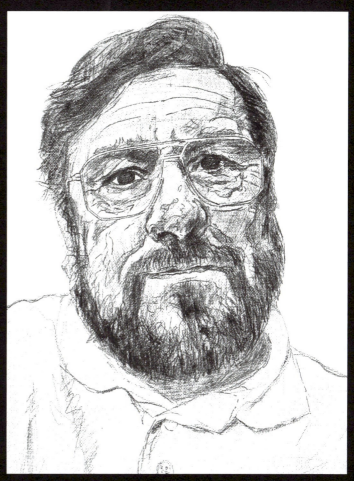

◬ The pencil sketch developed gradually and more detail was added to the eyes and hair. I also applied some tonal elements for reference when working up the painting.

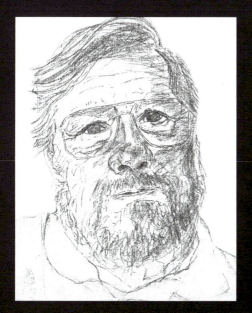

◬ The pencil sketch was reasonably detailed and it outlined the areas where I wanted to apply tone using oil paint. The sketch began to look more like Ricky at this stage!

Planning the portrait

I began the portrait, as usual, by drawing Ricky's features in some detail, using a 3B pencil straight onto a canvas board. I felt that I knew his face very well after seeing it so often on television, so there was little need to do many preliminary drawings. I knew from the start that I wanted him to look directly out of the canvas so that whoever viewed the portrait would make eye contact with him. It was going to be one of those portraits where the eyes follow you round the room.

As soon as I began work on the drawing I realized instinctively that this portrait would have a presence of its own because the face I was painting had so much life in it. However, it was only after I had been working on the drawing for a while that I appreciated the irregularities in Ricky's face. There was no symmetry and no smooth areas. He reminded me of those gnarled olive trees you see around the Mediterranean with trunks so twisted and shaped by their environment that they take on a presence of their own.

◉ The underpainting developed the structure of Ricky's face because I angled the brush strokes to construct the main mass and form. I also added some indication of tone to his beard.

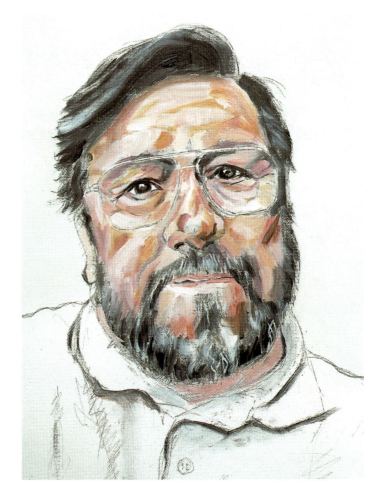

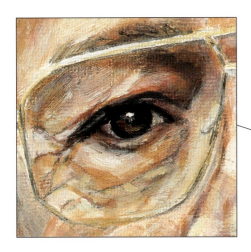

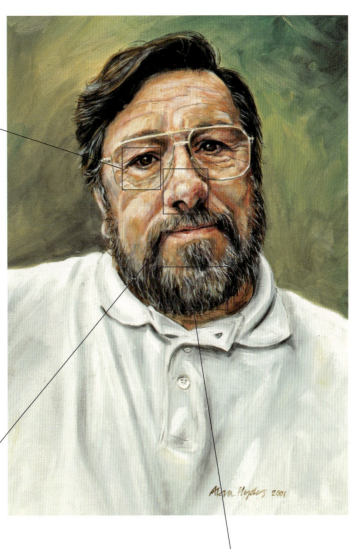

⚇ In the final portrait, I put lots of detail into the eyes. They really brought that 'lived-in' face to life.

⚇ Ricky's nose is a miracle of form! It is quite distorted and misshapen but it adds great character to his face. He should get it insured.

⚇ Ricky's beard is 'salt and pepper' with lots of interesting texture and a variety of greys. Along with his fine head of hair, it provides a contrast to his features.

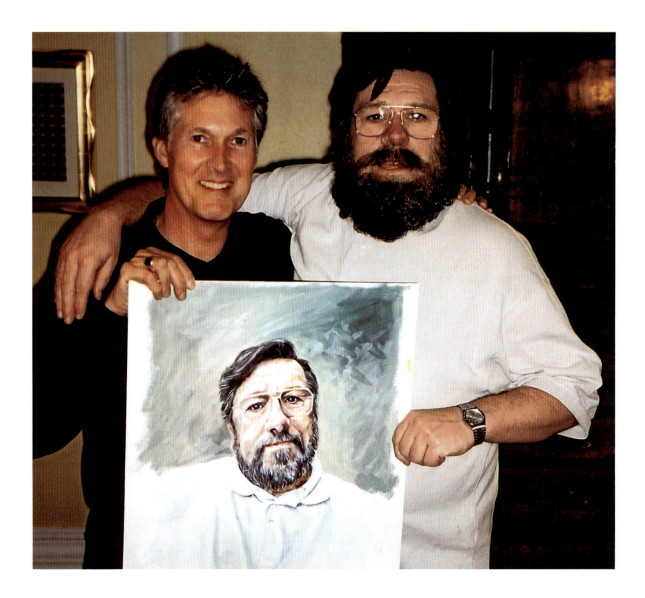

I found that I could be quite free with my brushwork, twisting and turning the hog's hair brush as I worked to give the painting a looser feel. It is so good to get expression into your actual brush strokes if possible. Ricky's portrait was highly textured with paint and when he saw the finished painting, he declared, 'I can see now why women fancy me!' He was so delighted with the portrait that he insisted that I have one of his abstract paintings as a gift. So my portrait of him now hangs in his home in Liverpool, and I have an original Ricky Tomlinson in my art collection.

ⓐ Ricky posed with the half-finished portrait wearing his false beard from the *Royle Family*. He wanted me to paint him with a trimmed variety so I used artistic licence.

ⓑ *Ricky Tomlinson*
Oils
55 x 40 cm (22 x 16 in)
The final portrait showed Ricky Tomlinson the actor looking in charge of his own destiny. He was so pleased that we have become friends in a mutual admiration society!

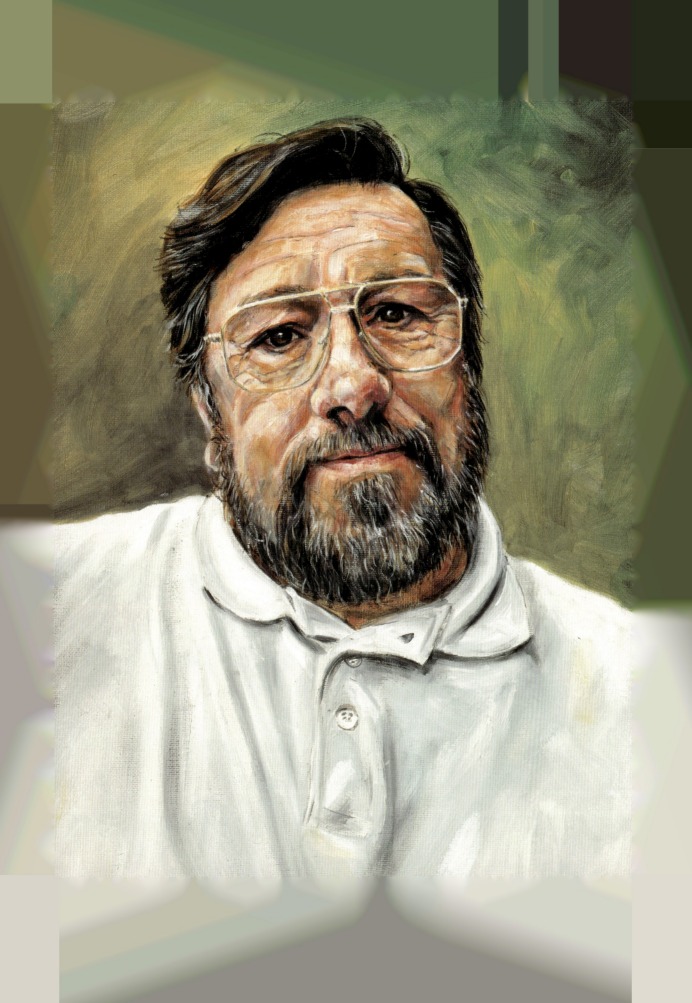

Lighting and positioning the sitter

When planning a portrait, consider how to light and position your subject. The greatest painters, especially Rembrandt, used light to simulate mood and atmosphere. Before Rembrandt, dark areas had created recession while brighter light had an optical effect of advancing towards the viewer. He changed all that in a stroke of daring, often setting the most brilliant areas at the rear of his composition.

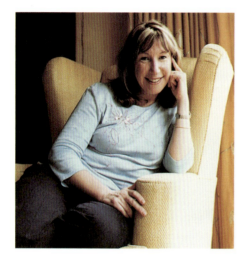

Balancing light

For the most part, Rembrandt's portraits were lit from above or from one side, creating the most perfect chiaroscuro (the balance of light and shadow in a picture). Learning how to balance light in a painting is very important If you don't visually balance the tonal area, your painting will look wrong and uncomfortable on the eye. Unless you balance the weight of shadow to one side of a portrait with some light areas, the result will be unbalanced. Equally, the way in which you position your sitter must not only be a pose that best describes them but must also balance visually on the canvas.

Painting Kay Mellor

When I planned on painting Kay Mellor to illustrate my thoughts on lighting and positioning, I chose a pose set against a window which made full use of the available light.

Later on in this book (see page 50), I will describe how I chose the images from a photo session with Kay, but I want now to explain my methods of employing light for dramatic effect. Kay is a distinguished writer and actress so I wanted to portray her in a creative style, visually.

I photographed her standing against a large window at her home in early April, and the light was soft as it flooded in through the glass. As Kay looked into the lens, I knew that I had an enchanting image to work from.

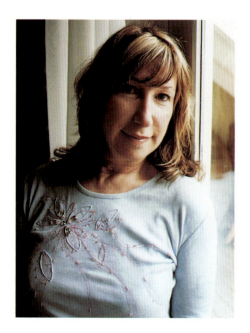

 I took a series of photographs of Kay at her home where I knew she would feel most relaxed. I used natural light to help create mood.

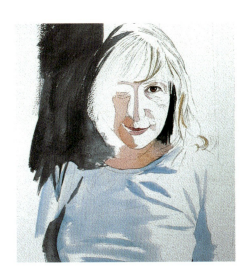

▶ I used Payne's Grey and very gentle colour to create the distinctive chiaroscuro effect.

Back in my studio I worked from the photograph, keeping as much of the original atmosphere as possible. I drew out the image in pencil and then decided which medium would best describe the mood captured on film. Kay's eyes were very expressive and her mouth set in a gentle smile so I chose watercolour washes to describe the image, keeping the execution simple but quite strong in terms of tonality.

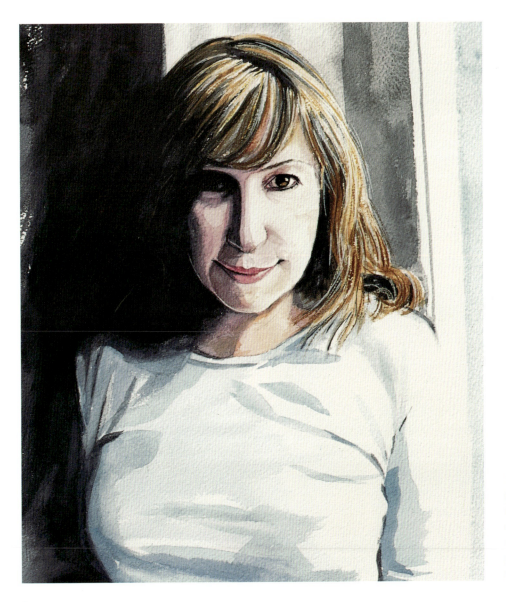

◀ The watercolour I produced of Kay had a moody, atmospheric quality and was more impressionistic than a photographic-type representation.

Barbara Dickson

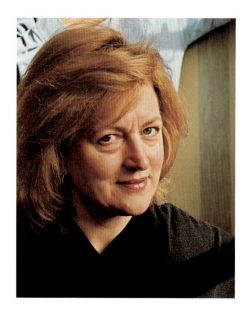

Lighting played a major role in my painting of Barbara Dickson. So much of her professional life has been spent on stage under atmospheric lighting conditions that it seemed to me very fitting that I should produce a portrait utilizing moody chiaroscuro (see page 34).

When I met Barbara, I was aware of the natural light coming from the main window. It was partially filtered by a very thin net gauze curtain, creating wonderful, soft light.

I posed Barbara in the light and took a roll of film, making sure I had perfect light on her face, but allowing her hair to be shadowed. The effect was as if there was a soft spotlight on her face, rather like stage lighting. The photographs conveyed not only her warmth but also made her look rather dramatic with so much light and shade.

This was a classic example of how to utilize natural phenomena to provide lighting that was sympathetic to the personality of the sitter. Many of my favourite portraits were painted using natural light which is simpler and more time- and cost-effective than setting up expensive artificial lighting.

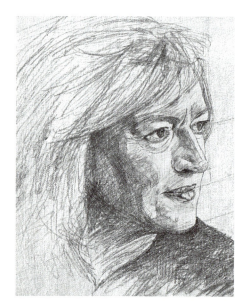

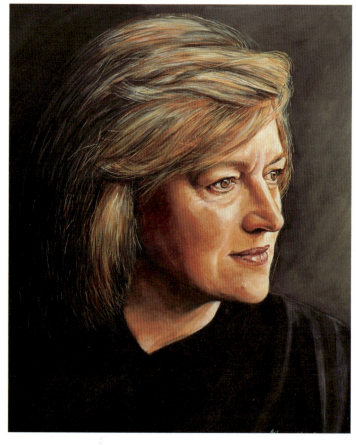

⊛ The pencil drawing was very much a way of designing the portrait in terms of the balance of light and shade and form.

⊛ Barbara is a singer and actress and so it seemed appropriate to produce a portrait which used atmospheric light.

Sir Bernard Ingham

During his years as Private Press Secretary for the then Prime Minister, Margaret Thatcher, Sir Bernard Ingham was seen regularly by millions of people on television. He always appeared very serious, almost grumpy, with an air of authority.

Meeting Sir Bernard changed my opinion of him dramatically. Yes, he could be serious and authoritative, but he also came across as a man of great compassion and humour. How was I to describe his character in my portrait of him?

I decided to position him in a way that avoided his direct gaze in a light that would illuminate one side of his face more than the other in order to provide more form in his features and exaggerate the main structure of his face. Like Lord Healey whom I had previously painted, he had a fine pair of eyebrows and I wanted to make the most of them.

I used energetic brush strokes, keeping the paint moving and mixing the soft pigment as I worked. The contrasting light throws Sir Bernard's features into a series of strong forms, creating depth and making those eyebrows stand out almost like a bas relief.

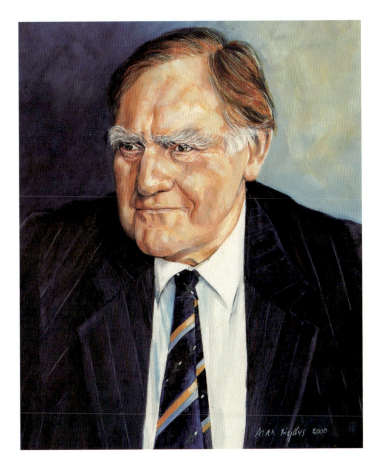

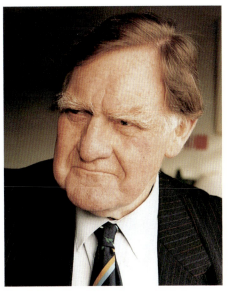

◉ Because Sir Bernard was wearing a dark blue pinstriped suit, it gave me the chance to merge it into the dark blue background, throwing his face into strongly contrasting light and making the form of his chin and cheeks highly structured.

Sir Edward Heath

Sir Edward Heath has only ever had four portraits painted, so it was an honour to be given the opportunity to create a portrait for the latter period of his life. It was also a pleasure to paint a face with so much character and experience etched into it. It is a face that not only shows his intelligence but also the fact that he has carried huge responsibilities and obviously experienced his fair share of sadness. I could not wait to begin what turned out to be a challenging portrait.

The portrait sitting took place at his wonderful home overlooking the Cathedral in Salisbury. I had made arrangements with him to paint the portrait outdoors in his garden as it was summer and the light was particularly good. I was so looking forward to coming face to face with the man and as I arrived at the gates to his house early in the morning I began to feel some nervousness. My anxiety was exacerbated when the armed police who guard his home met me. I was frisked and my painting gear was examined. But soon I was sitting in his home with a cup of tea and biscuits, awaiting his presence.

While he was getting ready for the sitting, I explored the ground floor of his house. It was full of the trappings of an ex Prime Minister, and his art collection kept me occupied along with the fabulous models of his sailing boats which had given him so much pleasure. The numerous political cartoons on his walls also brought back memories of his time in office.

Born in 1916, Sir Edward Heath was elected to Parliament in 1950. He entered the Cabinet in 1959 and became Leader of the Conservative Party in 1965. After the 1970 General Election, he became Prime Minister and, during his premiership, he took Britain into the EEC. After 51 years as MP for the same Constituency, he made his farewell speech at the age of 85 in May 2001.

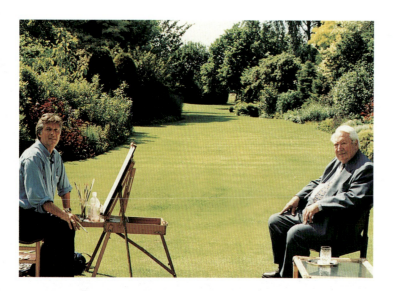

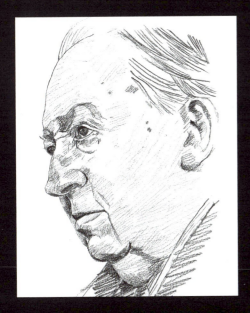

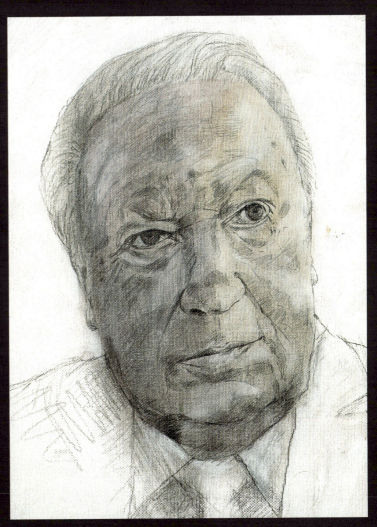

◬ It was important for me to try out various angles of observation, and I actually liked the character which emerged from the drawings I had made from Sir Edward's left side. However, the more frontal position captured his features in a more thorough way.

◬ My big drawing was done directly onto canvas and was as detailed as possible in order to give me as much information as I needed to go on to use oil paint in a more structural way.

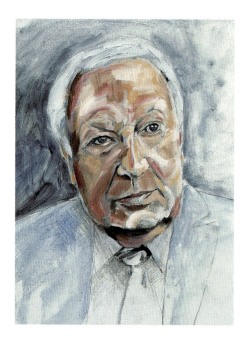

▼ I began to apply colour to the drawing, using exaggerated skin tones and quite thick paint. I wanted the texture of the paint to enhance the structural elements and to provide a strong underpainting.

Planning the portrait

I began the sitting by positioning Sir Edward to take advantage of the excellent clear light. His face is quite complex and I had to put a lot of work into understanding those complexities. When you are painting someone with a lifetime of experience in their face, try to give yourself the best possible illumination on the features to begin with. Low light conditions can make it difficult to see all the small but important changes in the overall shape of the features. In an older person, the face is more affected by gravity and often eyes and jowls need keen observation to capture them accurately. Never set off with a preconceived idea as to how your sitter's features look.

Always draw your sitter with good light on their face from different angles and really measure those features. I drew Sir Edward from various angles before I chose the position from which I wanted to paint him.

I decided upon a portrait with his face almost full-on, yet with his eyes looking away at an angle, as if contemplating the future. His eyes are thoughtful and expressive, best shown off with lots of detail and light reflecting off the surface.

Lighting Sir Edward

In order to create the impression that your sitter's face has substance and form, you should consider lighting your subject from above at an angle. Darker tones below the chin focus the viewer's eyes on the main features. By deciding to paint Sir Edward outdoors, it was possible to allow the sunlight to create the effect naturally.

The only problem with working outdoors is that your light source moves around during the day. It naturally fell to one side of the face, however, towards the latter part of the day, allowing me to take full advantage of the gentle illumination.

The light on the finished portrait was to be from the left side, in order to build form into the face, so as I worked on the painting I slightly emphasized the contrast. A few weeks before the main sitting, I had visited Sir Edward at his London home and produced some sketches and photographs for reference so I had a clear idea as to how I wanted the mood of the lighting in the finished portrait.

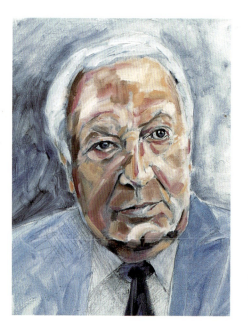

◄ I developed the painting quite quickly and pushed the paint around in a fluid way, working wet on wet. Once I had completed the underpainting, I let it dry completely before applying the glazes.

One of Sir Edward's eyes is quite a bit lower than the other which becomes even more noticeable when he tilts his head slightly to one side. His eyes show intelligence and experience.

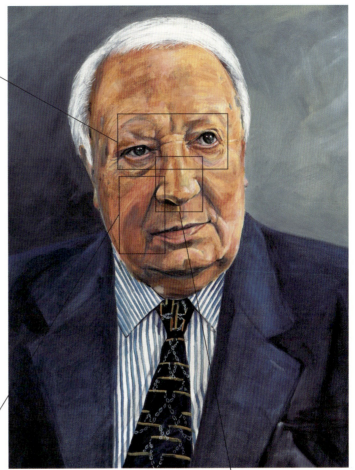

Getting some weight and mass into the face is simply a matter of following the angles that the flesh creates naturally.

Painting noses is very much about looking at the way the light reflects off the various angles. If you paint exactly what you see, and observe the tones carefully, you will get the nose to appear as though it is standing out from the face.

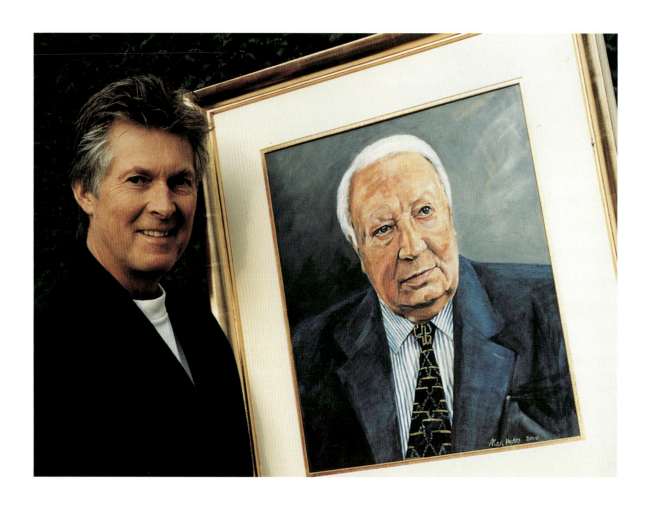

Creating the skin tones

If you are painting an older person, make the most of their best features. Sir Edward has a wonderfully strong head of white hair, for example, which sets off his skin tones well. In good bright light, white hair is shown off to best advantage.

I purposely painted in a neutral, mid-tone background to emphasize the silver-white hair and create a tasteful backdrop. The dark suit and striped shirt added some order to the quite complicated shapes and skin tones in his face.

The light on his face in the finished portrait comes from the top left-hand side, giving softer, darker skin tones to the right-hand side. This helped to create a face with lots of form and strength. I also painted light reflecting in his eyes which helped to emphasize his intelligence and knowledge.

⊕ The portrait was life-sized and I framed it in a 24-carat gold leaf frame. When it was presented to Sir Edward he said, "I like it very much. It is thoughtful and shows that I have a complete grasp of the situation. I'm looking towards the future which is good – although I might have put on a different tie!"

⊕ *Sir Edward Heath*
Oils
55 x 40 cm (22 x 16 in)
There are only four portraits of Sir Edward in existence because he nearly always refuses to have his portrait painted. I was pleased with the finished portrait because I felt that it represented a former British Prime Minister in a dignified and yet very natural pose. It now hangs in his house in Salisbury.

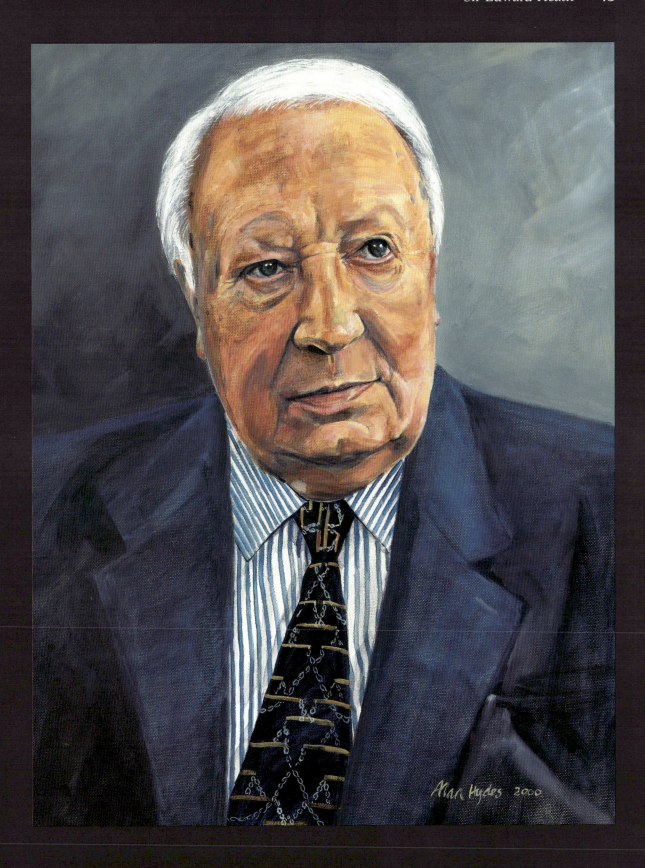

U sing photography

Many portrait painters now use photography as an aid to accuracy. Although some people feel that it is 'cheating', over the centuries painters have used many devices, such as the 'camera obscura', 'camera lucida', lenses and mirrors to provide them with an accurate image of their sitter. In the end, it is what you as an individual put into your work that gives a portrait its special quality.

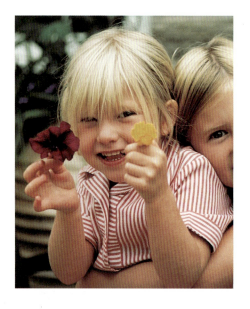

Painting children

Photography is especially important when painting children. Young children hate sitting still; many simply can't! So one way to get a permanent image of a child is to take a photo. Take my portrait of Lucy and Rebecca Dransfield, for example. Without my camera I would never have been able to capture such a natural pose to paint. Neither of them could have sat still for more than a few seconds! However, when I went to their house, they were just home from school, relaxed and happy. A half-hour photo session provided me with some fabulous pictures which revealed their individual personalities, but it isn't just a matter of aiming a camera at your subjects.

To bring out the best in children, you have to entertain them. This will take their minds off the camera so that they relax and perceive the photo session as fun. I began by involving their mother, who distracted them from behind me. Once Lucy and Rebecca felt at ease with me, I encouraged them to enjoy themselves. Lucy began playing with a flower she had picked which took her mind off my camera and me.

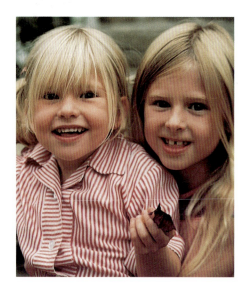

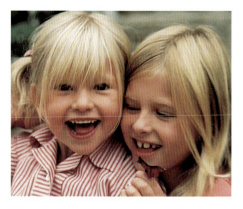

◉ Taking effective photographs of children and allowing them to be totally natural is an art in itself. I shot most of these pictures using a telephoto lens so that the girls did not feel self-conscious about the camera and would behave naturally.

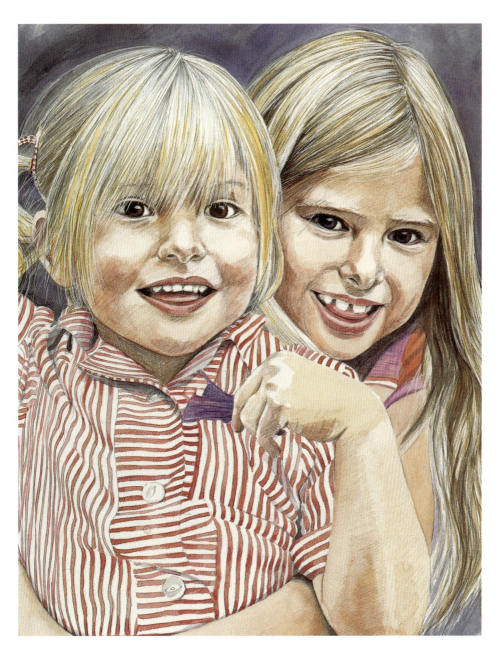

◉ The finished watercolour is very large and has an enormous amount of detail, but it still retains that essential watercolour feel which allows the skin tones of Lucy and Rebecca to be soft and gentle. The striped shirt helps the contrast with the flesh tints and provides dynamic pattern quality.

The best tip I can give you when photographing children is to let them have their own space. Let's face it, anyone gets self-conscious if you point a camera at them, so get as far away from the children as possible and use a telephoto lens. The actual image in a good telephoto lens is also good because there are no distortions of the kind you get using a wide-angle lens, for example. I used a combination of photos for my final image of Lucy and Rebecca. I think you will agree that the end result is very natural and the girls look as though they are really enjoying life.

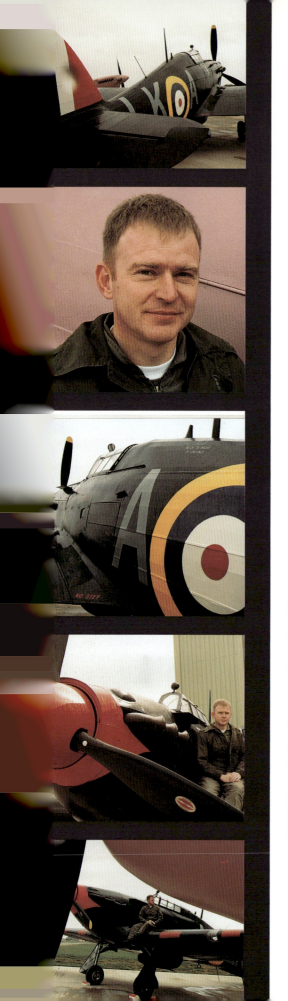

Using photography for scale

When planning a large portrait of Robert Fleming and his Second World War fighter aircraft, I took lots of photographs. The shape of the aircraft was important, and the livery was easy to replicate, but what I needed to achieve from my photographs was an understanding of the scale of the aircraft against the sitter. I wanted to get lots of different viewpoints (as shown left) in order to take the necessary decisions about the proportions of the final painting.

I began by taking a series of photographs of the fabulous historic aircraft from different angles. Then once I had taken enough pictures to give me a full understanding of their structure, I asked Robert to sit on the wing of the larger plane – the Hurricane - to give some idea of scale. More

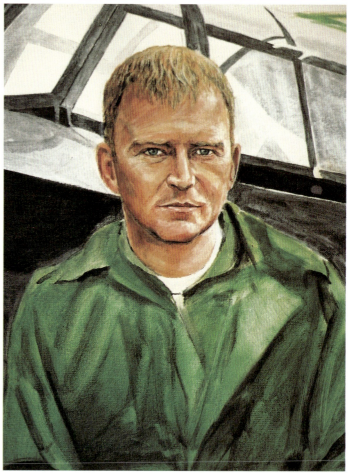

⊕ I depicted Robert looking straight towards the observer. I wanted him to look confident and at ease with his favourite aircraft around him.

importantly, I wanted to elevate him from the ground to create a sense of ownership, and to give me a good angle on his features to best describe his character. I took four or five rolls of 35 mm film before I was satisfied I had a series of images I could combine to make a perfect composition.

I had large prints made of every frame and laid them all out on my studio floor. I then began a process of elimination in order to sort out the best images. It was a time-consuming activity, but a very important one. It soon became clear how I could use the images to best effect and I decided that the distinctive Spitfire (originally a reconnaissance aircraft) would be featured flying low in the background across the canvas against a dramatic sky with the Hurricane in a dominant position in the foreground of the painting.

⬇ The finished painting had all sorts of dynamics running through it with the Hurricane forming a huge structure containing lots of different textures, colours and shapes. The landscape served as a backdrop, adding depth and green tints and contrasting with the darker colours of the aircraft.

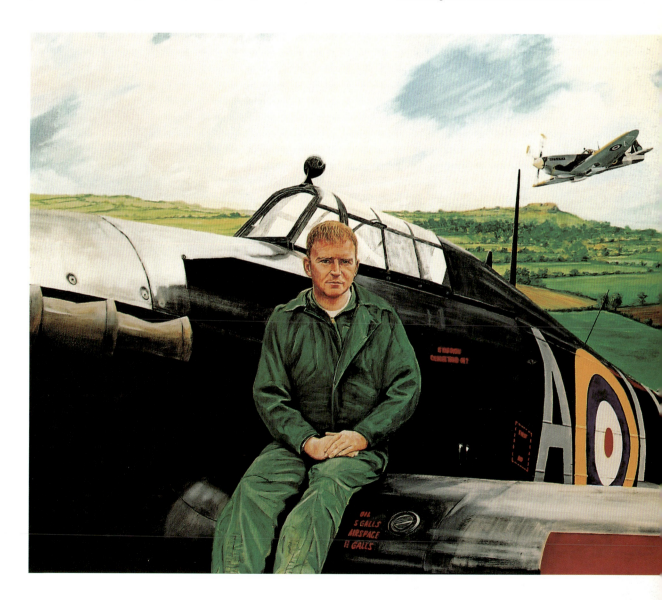

Creating interesting portraits

When I painted the triptych of the Blackburn family, I had a challenge on my hands because I decided to place all three sitters in a line. I also wanted the boys to be relaxed and comfortable, so hours of sitting in a studio were not really an option. The solution was to work from a series of photographs. I arranged a sitting with the boys, Hugo and Barnaby, and their mother Louise on a bright late spring day and took a range of photographic equipment, including a 35 mm single lens reflex camera and three different lenses – a 28 mm wide-angle, a 50 mm standard and a 135 mm telephoto.

Initially, I photographed all three sitters together in order to get a feel for the composition, trying out different poses. I did this with a wide-angle lens in order to maximize the image in the frame. I then used a 50 mm standard lens to take full-length individual shots to get the details of their clothing, etc.

Finally, I used the telephoto lens to take photographs of their individual faces. People react more naturally to having their photograph taken if the lens is a good way from their face. It makes them more relaxed and less self-conscious. Having taken several rolls of film, it was then a matter of selecting which photographs to work from.

It is sometimes a good idea to depart from the conventional way of portrait painting in order to produce more interesting images. With all three sitters in a line, a long, conventional canvas would have looked strange, so I decided to work on the painting as a triptych – three canvases joined together with an individual subject on each canvas.

I also decided to have some shaped canvases specially made to make the painting even more interesting. They broke up the shape of the painting surface, thereby providing an 'object' in themselves.

▼ I took lots of 35 mm shots of Hugo, Barnaby and Louise sitting in the summer sunlight. The relaxed poses translated well into a big triptych, and the dappled sunlight gave the painting more atmosphere. I loved the way in which the big wicker chair flopped over to one side, giving the painting less symmetry and breaking down the horizontals and verticals.

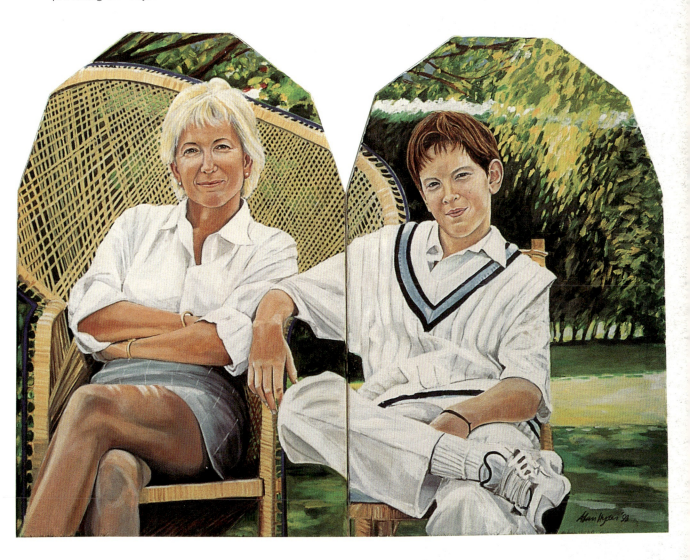

Creating informal portraits

To produce an informal portrait of Kay Mellor I took lots of photographs in different settings and lighting conditions. Kay has a very expressive face and her eyes are particularly good at showing emotions. As an actress and writer, she observes and understands the most subtle facial expression, so my photography utilized both my skills and hers.

I began by taking photographs in a very gentle light with her face illuminated by natural daylight flooding through a window. I sat her in a large, comfortable chair and used a 50 mm standard lens with no additional light as I wanted the photos to be as natural as possible.

I took the photographs in Kay's living room where she would feel relaxed and comfortable. The results captured her warmth and the atmosphere of the room.

If you want to get the best from your sitter when taking photographs, try to make them as relaxed as possible and don't be too demanding. Make them feel happy with the way you work by telling them what you are trying to capture on film. Sometimes I know instinctively, as the shutter clicks, that the photo is a good one and I always let my sitter know so they can share my confidence.

After taking the indoor shots, we went out into the garden for an informal shoot. We decided to use a piece of garden furniture as the main prop and Kay put on a denim jacket to give the images a more everyday look. She posed naturally with her back against the seat back, and the angles of her arms and legs helped lead the viewer's eye to her face.

However, these photos did not reveal any clues as to her profession so I decided to incorporate some imagery which would say something about Kay the writer – her many awards. If you want to produce a portrait that says something about your sitter's occupation or interests, then try to incorporate something into the picture which endorses their success. Tools of the trade can add further points of interest to the composition and introduce pattern quality and perspective.

Rather than have Kay posing against a studio background with cameras and lights or a large showcase full of her awards, I wanted to continue the informal theme. Therefore I arranged lots of the more visually interesting awards on a low broad table and asked Kay to pose besides them. The result was a unique image of a highly successful writer

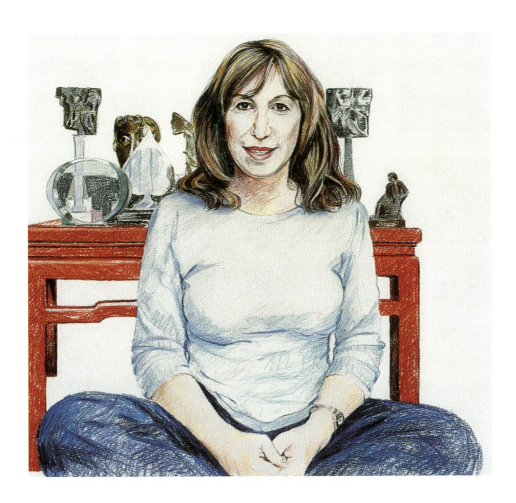

sitting amongst some of her most prestigious awards, looking very happy and relaxed.

To make it look even more informal, Kay posed cross-legged on the floor in front of the table, holding the BAFTA award which is her most prized possession. The other awards formed a backdrop to the main portrait. Finally, before completing the photo session, I took some pictures of Kay against a large window just looking straight into the camera to contrast one side of her face from the other. The pictures looked moody but expressed Kay's character.

Photography had played a vital role in capturing an image of Kay which would have been virtually impossible in any other way. She could not have held the pose in any of those positions while I drew her, and the expression on her face would not have been as natural and relaxed as the image captured at the speed of a camera shutter.

⊕ This coloured pencil drawing captured Kay in a very relaxed mood with her awards behind her. it portrays Kay as a successful woman who is proud of her achievements, but her clothes state that she is very un-fazed by such acclaim.

Dame Thora Hird

Meeting Dame Thora at her mews home in Bayswater was a real thrill. I had admired her so much over the years and it was a great privilege for me to paint her portrait. Getting to know her proved to be a wonderful experience as she was just as I imagined her – down to earth, sincere, intelligent and warm, with a wicked sense of humour! She was almost the same age as my mother and this helped to give us an instant rapport. We warmed to each other and the friendship that developed between us lasted until her death.

I was once asked for my wish list of people I would most like to paint: Thora was right at the top. Her face was a picture of contentment and warmth with extensive worldly experience etched into it. It was an open face; she hid little. Her mews house was full of memorabilia. A table in the hall groaned under the weight of the awards presented over the years for her superb performances in so many memorable productions. Her acting skills got better and better, stretched by Alan Bennett's incisive writing.

Thora Hird died in March 2003 aged 91. One of Britain's finest character actresses, her career spanned 80 years. She made more than 100 films as well as starring in TV comedies. Her performances in *Talking Heads* and *Lost for Words* won her BAFTA awards. She was awarded the OBE in 1983 and made a Dame of the British Empire in 1993.

I visited Thora several weeks before starting the portrait as I wanted to take some photos of her as reference for some initial sketches. Because of her age it was important to minimize the discomfort of staying perfectly still for several hours. Besides, I knew she enjoyed talking and I was sure she would be animated when I began the portrait.

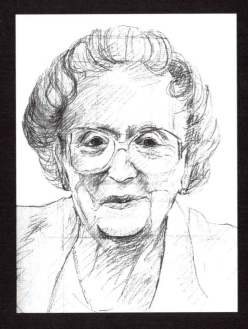

⊘ The sitting began with me just plotting out the facial structure, trying to get a general feel for the positioning of Thora's main features.

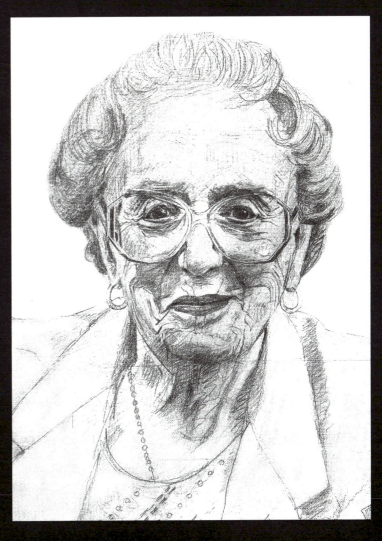

⊘ I worked directly on to the canvas and produced a very detailed pencil sketch which had all the information I needed to develop the painting. It was important to capture Thora's character at this stage.

Planning the portrait

I photographed Thora from different angles to get a feel for her facial structure. When I went through the photos, some were too posed and a little unnatural whereas what I really wanted was an image of her looking towards me, making eye contact and expressing that fabulous warmth. There was no suitable picture so I produced a few sketches to familiarize myself with her features before the first sitting. I positioned my easel and chair well above Thora's eye level as I wanted her face to look slightly upwards, thereby taking some weight off the jawline. I also wanted her eyes towards the top of the lenses of her glasses – portraits look better when the eyes are not central in the lenses.

I began with a detailed drawing in pencil on canvas, spending lots of time on the sketch because I wanted it to be as accurate a representation as possible in order to capture every millimetre of her character, and it was all there in front of me. Her remarkable face told the story of her life.

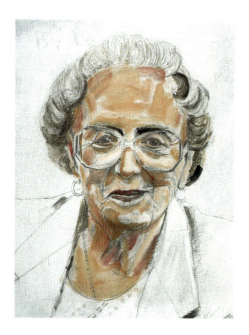

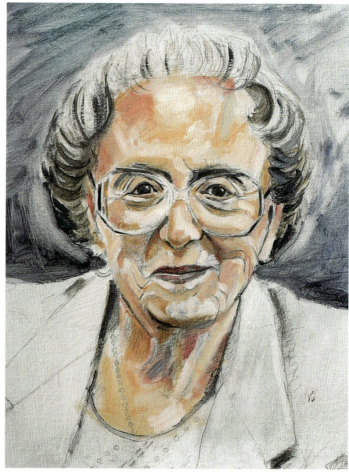

◬ Working on top of the drawing, I began adding colour to build up the structure of the face in oils. My brush strokes modelled the face and the colour overemphasized the skin tones.

◉ This gave me the chance to switch from hog's hair brushes to sable in order to apply glazes over the more thickly applied paint.

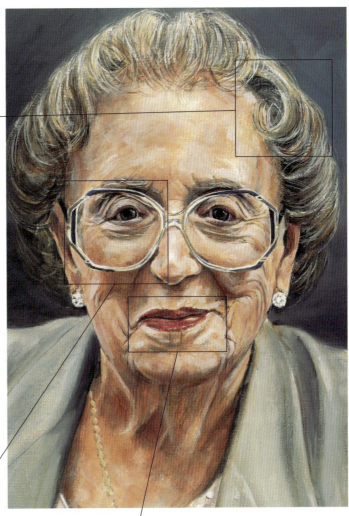

◉ Thora was very proud of her hair and I tried to do it justice by painting almost every hair. She asked me to add a bit more to the density of it as she felt that it could do with a volume boost!

◉ Thora's eyes were wonderful and so expressive. Full of experience, they had a twinkle which betrayed her incredibly infectious sense of fun.

◉ Thora's mouth went up at one side and down at the other when she smiled. It was an enigmatic smile which gave her great character.

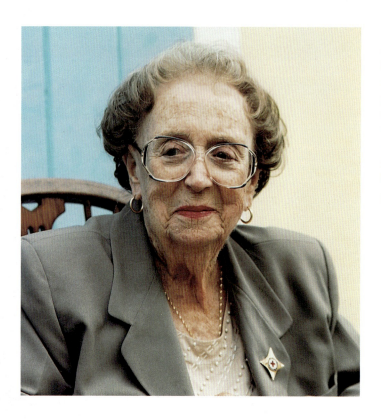

◀ Thora looks quite serious here but she later joked with me as she signed the photograph of us together, "Have you come to paint the skirting boards?" It was a privilege to have met her and painted her portrait.

▶ *Dame Thora Hird*
Oils
55 x 40 cm (22 x 16 in)
This is the finished portrait which Thora loved. I tried to portray her with dignity and pride but, being Thora, she looked as though she was about to tell a scurrilous story or crack a joke.

Producing the portrait

After drawing the detail of Thora with a wry but warm smile on her face, I then got to work with oil paints – underpainting first of all and then developing the angles and planes of her features. As the painting developed, it became clear to me that her eyes were very special indeed – full of knowledge and acute awareness.

As I worked away on the portrait, Thora chattered away non-stop, telling me about her life story and her childhood memories. She described her husband, her professional involvement with Alan Bennett and, of course, her daughter Janette Scott, on whom I had had a massive crush when I was a teenager. I even had a big photograph of Janette Scott on my studio wall, cut out carefully from a *Sunday Times* supplement. This amused Thora no end but she did concede that Janette was a real 'beauty.'

After building up the skin tones, I got to work on her hair. It was a very gentle golden-brown colour of which Thora was very proud. Even though it was still thick, she asked if I would thicken it up on top – which I did!

The painting was a joy to work on and when I showed the completed canvas to Thora, she said she 'loved it', which was a great compliment to me.

Alan Hydes '00

The importance of sketching

I never begin a portrait without fully understanding the structure of the face that I am depicting. I have to create a foundation to work from which is strong in visual awareness of the physical make-up of my sitter's features. To explore these effectively, you must produce as many sketches as possible from different angles so that you are fully conversant with all elements of the physiognomy.

⊕ Drawing Gaynor was great fun because she enjoyed posing, and this provided me with the opportunity to draw her from many different angles. Using a 3B pencil, I worked quickly with quite a lot of fluency in the line.

Gaynor Faye

When I was painting actors from the cast of *Coronation Street*, I had a great time producing lots of drawings of those familiar faces. Gaynor Faye was playing the role of Judy Mallett, a rather brash-looking woman, so when I met her in the flesh I was fascinated to discover that Gaynor was very striking to look at. Her face was strong and vibrant and she was trim and curvaceous. I decided to produce some full-length sketches of her along with detailed facial studies.

Gaynor had a natural ability to pose well and this helped me to capture her likeness through some quite simple drawings. When you are producing preliminary sketches, consider the poses carefully if you are intending to paint a full-length portrait. An awkward pose will be evident in a finished piece of work, so make sure your sitter is relaxed and in a typical pose that best describes their character.

When drawing Gaynor, it was obvious that her hair would have to feature very strongly in the finished portrait. The way in which it fell over her shoulders, cascading down her back, gave the painting wonderful pattern qualities and also energy through the curvilinear forms. It set off her features perfectly and framed her face in a natural way.

It is always difficult to paint a portrait of someone whom you see regularly on the small screen. However, it is even harder when you have been familiar with the face for several years. So I had to do my measuring and stick to the reality of what those measurements told me. I think you will agree that the finished portrait is miles away from the image of Judy Mallett whom we see on TV.

⊕ After producing a pencil drawing, I did a watercolour sketch but I had overemphasized the angle on the cheeks, so I took some of the colour away by lifting it off with a wet sable brush to provide a softer effect for the main portrait.

⊕ Working in pencil and watercolours can enable you to produce quite detailed studies of your sitter's features. Gaynor has superb bone structure and very engaging eyes. Her hair at the time was long and flowing, framing her face perfectly, so I decided to make it an important part of the portrait. The flow of the lines created an energy which enhanced the feel of the finished painting.

Bill Tarmey

Known to millions of television viewers as Jack Duckworth in *Coronation Street*, Bill Tarmey provided me with a challenge. He had strong features and I felt that I had to produce lots of sketches to be sure of capturing his real-life character as opposed to his television persona. I used a 4B pencil to map out his features, looking at them from different angles. The drawings were relatively simple in terms of the amount of detail, but they allowed me to fix in my mind the way his face was made up. I also used this sketching exercise to analyze the effects of magnification on his eyes through the strong lenses in his glasses.

Finally, I produced some more detailed drawings, using watercolour washes in a loose way, to give me an accurate indication of the flesh tints in his face and also the colour of his clothing.

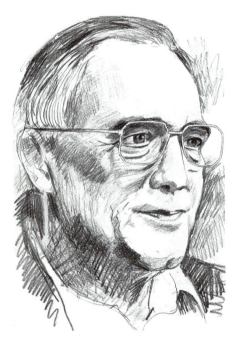

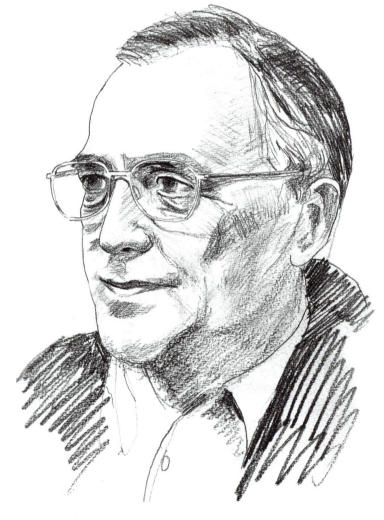

◬ Bill has strong features and a face that can look quite solemn and pensive. I tried to capture these qualities in my drawings.

▶ The pencil sketches of Bill gave me an opportunity to get to terms with the tricky problem of portraying someone who is wearing quite high-magnification glasses.

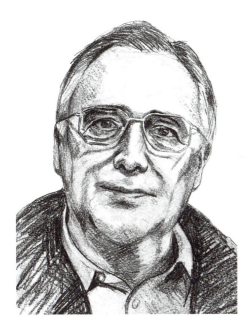

⊕ I decided that a more developed head-on drawing of Bill would best describe his personality. His eyes seemed full of pathos and the drawing showed he enjoyed being painted.

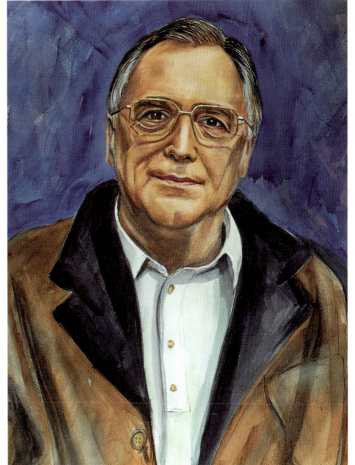

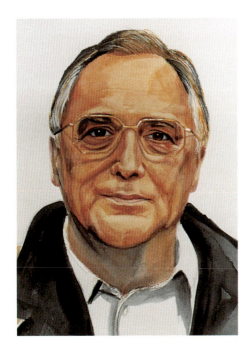

⊕ Working with watercolours, I built up the tones quite strongly initially. However, I later felt that they were too strong when I looked at the painting with a background tone included.

⊕ So I lifted out some of the colour right across Bill's face, using a size 7 sable and lots of clear water. The effect softened the image and made the portrait much more accurate.

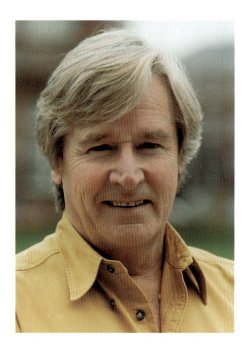

William Roache

Bill has probably the most recognizable face of any actor in the UK thanks to his role in *Coronation Street*, playing Ken Barlow since the very first episode in 1960. He is the only remaining actor from the original cast still appearing on 'The Street' (as it is known in the business). So, as you can imagine, I had a very well-formed preconceived idea about what he would be like in the flesh. Meeting him, however, and spending time with him allowed me to experience his real-life persona which I found to be moulded by his very interesting past as an Army officer serving in the Caribbean, his personal tragedy in the loss of a child, and, of course, his remarkably successful life as an actor.

So I drew Bill's face not so much to get an awareness of his features, but more to seek out an expression that described his personality. Sketching became my way of looking at the variation in his expressions and a tool to

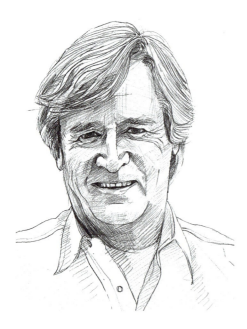

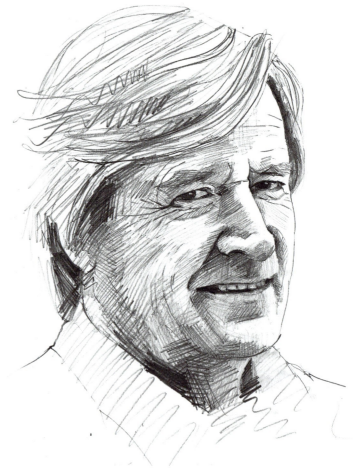

ⓐ I tried drawing Bill looking straight at me but felt that it did not really capture his personality as it was too flat-looking.

ⓑ I gave Bill's face more angles and points of interest, bringing the features into a half-profile and emphasizing the shape of his nose and chin.

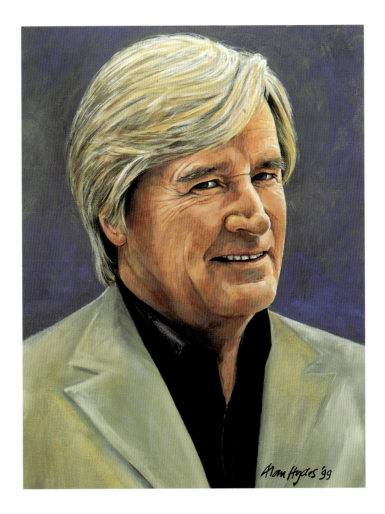

◐ The finished portrait gave Bill the look of a film star – confident and pleased with his lot. But the eyes had a look of curiosity as if he was wondering what the finished portrait might look like!

capture a look that was William Roache and not Ken Barlow. I tried drawing his face from different angles with slight variations to see how best to express my perception of him. He is often quite serious in his role on TV but I found him to be lively and much more of a free thinker – far more fun than Ken. I needed to catch just a glint of mischievousness in his eyes. The problem I had was that he was so accustomed to being observed and therefore it was harder to get under his skin. What was immediately apparent was that he had a very thick head of hair and a rather good bone structure – of which he was rightly proud – but finding the tiny details in his facial expressions was very difficult.

The drawings I produced were in pencil on a cartridge paper, and I pushed them around quite a lot, using a putty eraser to correct any elements I was unhappy with. Finally, I decided on an angle that best showed off Bill's features and gave him a knowing look. The final drawing was on canvas board and it formed the basis for the main painting.

Richard Whiteley

Richard Whiteley is a cult figure to many people who see him as 'Mr Countdown', the quirky question master on a daytime television show. I know him better from his days as a news reporter and presenter for Yorkshire Television's daily news programme, *Calendar*. Others around the world know him as 'the ferret man', since he was unfortunate enough to have a full-sized ferret bite him (and refuse to let go!) on live television, which became the most famous 'out take' of all time.

Richard and I have been acquainted for a long time as we worked in the same television studios. So when I painted his portrait it was quite difficult not to allow my preconceived ideas about Richard's maturing features to influence my work. He has never been a shrinking violet, and his choice of attire is not subtle in its colours or patterns. Richard favours eccentric, exciting clothing which makes him stand out from a crowd, and that says a lot about his personality. So not only had I to consider his facial characteristics but also his personality traits. In the end, I decided to give him a slight smile, but nothing too emphasized. It was just enough to show his sense of fun and portray his personality in a relaxed way.

A born and bred Yorkshireman, Richard achieved fame fronting Yorkshire TV's evening news programme. In 1982, he was the first face on Channel 4 and, 21 years later, *Countdown* is still a popular programme, attracting millions of viewers. Renowned for his colourful clothes, he loves cricket, racing and the Dales and is the Mayor of Wetwang.

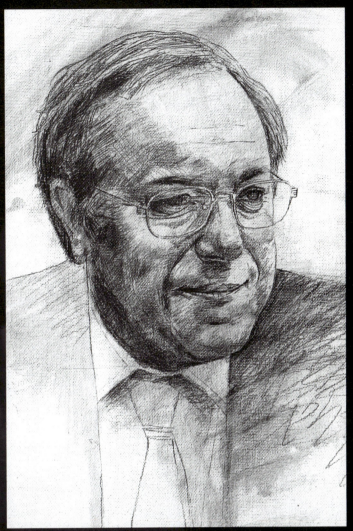

◬ Richard looked mischievous in my initial sketch which showed him in profile. I liked the impression it gave but felt that a more full-face depiction would better describe him.

◬ I developed a tonal drawing using 5B and 6B pencils before adding any colour. The tonal elements brought the drawing to life so it was then a matter of introducing underpainting to develop the structure further.

◬ I measured out Richard's features carefully and made sure his glasses produced the correct magnification of his eyes in the drawing.

Planning the painting

I knew that what I had to achieve was a portrait that showed Richard pleasantly pleased with his lot. The only way for me to bring out his personality was to try out a range of drawings from different angles in an attempt to find a pose and expression that typified the man.

Richard is by nature an extrovert – he has to be because of his high profile on television. He plays up to his role by wearing brightly coloured blazers and ties, and he usually has a friendly and approachable look about him. When it came to producing preliminary drawings, I did not want him to be too serious. When you are drawing someone with a personality like Richard's, you have to capture the essence of the man, and that is a difficult task in many ways. It calls for some keen observation and poetic licence.

It is important to allow yourself expression in your line when working on preliminary drawings. I use a 3B pencil and keep it sharp. Soft-leaded pencils run easier on paper so they help to keep the drawing fluid. Working on a large scale is also beneficial. Try to produce drawings that are almost life size. That way you have to be freer with your line. Working on a small scale has a tendency to make people more precious in the way they use line.

Eyes and glasses

One of the good things about working on Richard's portrait was the fact that he wears glasses that naturally magnify his eyes. He has quite twinkly, bright eyes, full of mischief in many ways, so it was important to me that in the finished portrait they were his best features.

Remember that you can work with a sable brush over the top of your main facial structure to provide detail. Wire-rimmed glasses and strands of hair, for example, can be highlighted once the flesh colours have dried. I used a sable brush to colour in the stripes on Richard's tie – it was enough to make me reach for tinted glasses!

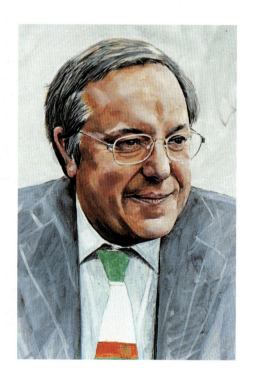

⊽ The painting emerged strongly and I added glazes over the underpainting, which warmed up the flesh tones.

⊳ *Richard Whiteley*
Oils
45 x 34 cm (18 x 13½ in)
The final portrait had dashes of colour in Richard's famous vibrant silk tie and jacket. His eyes looked away to the left, thus giving him a slightly thoughtful look.

Alan Hydes '2000

Facial structure and underpainting

Faces are complex and there are so many elements to consider when painting a portrait. Although we all look different, we all have eyes, a nose and a mouth. Surprisingly, many of us have a distorted idea of exactly where these features are positioned, so you should always measure your sitter's features before you start to place them correctly on the face. Then you can begin to develop the structure of the face.

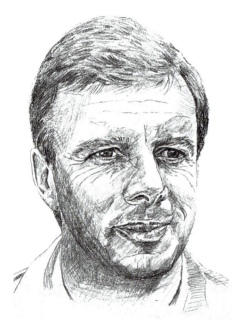

Positioning facial features

Most children, when asked to draw a picture of their mum or dad, portray them with a great big head and a tiny body. This is because the face is more important to them. The body is there, but it does not smile or talk. However, most adults who draw a face nearly always place the eyes about three-quarters of the way up the head. It is strange, but that

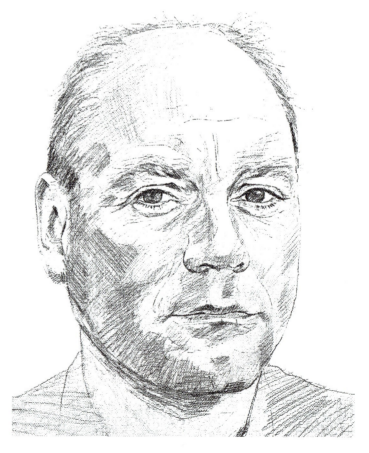

◉ My drawing of David O'Leary had to take into account the fact that at the time his nose was broken and bent quite strongly to the left. I did not want it to be obvious in the final portrait, so I chose an angle that would disguise it.

◉ This drawing of the Honourable Simon Howard analyzed his facial structure. The lines, applied with a 6B pencil, followed the planes of his face in order to emphasize the form.

is where people think the eyes sit. After all, a nose and a mouth must be fitted in below the eyes! In actual fact, the eyes are roughly halfway between the top of the skull and the chin, central in the head.

Analyzing facial features

I produce lots of drawings to describe my sitter's facial structure before putting brush to canvas. Spend time on analyzing their facial structure. Look carefully at the way in which the face is built up; analyze the angles, the weight of the form and the way in which the features fit. Describe the form by using modulating lines that follow the planes of the face. Imagine you are running your fingers down the features. What angle do the cheeks run at? How steep is the incline on the bridge of the nose? Use your eyes to explore the features.

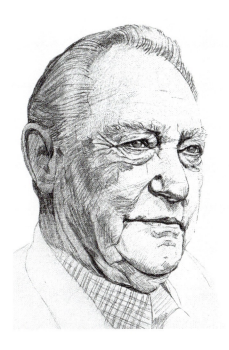

⊕ When drawing the face of an older man, you can use the character lines etched into it as a means of bringing out the sitter's personality. In these studies of the actor Richard Todd, I simply copied what I saw without any over-emphasis or exaggeration. His face was a dream to paint because there was so much going on.

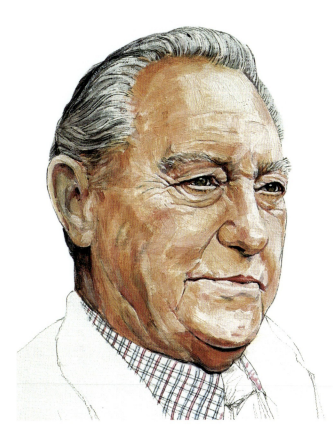

◉ Adding colour to the drawing soon brought out the form as I built the colour statements around the detail of the pencil drawing. A face with so much character demanded a very investigative approach in terms of seeking out all the different tints and shapes.

Underpainting

Once the drawing is complete, you can begin underpainting, using the drawing as a guide. I always underpaint my portraits to give them a structural foundation. I let my brush follow the angles and planes of the sitter's face, building up an almost sculptural underpainting on which to apply all the delicate skin tones.

You can use a special underpainting white or simply mix some Titanium White and Flesh Pink on your palette, without adding any turpentine or linseed oil. The whole purpose of underpainting is to allow the brush strokes to describe the structure of the face, giving it more form and texture. Of course, you can work directly onto primed canvas without underpainting, but I find that when my brush strokes are evident the effect strengthens and enhances the portrait, reinforcing the facial structure of my sitter.

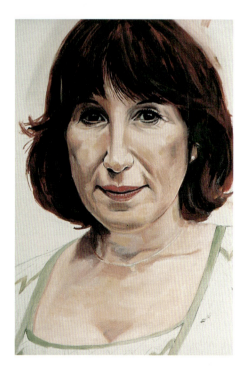

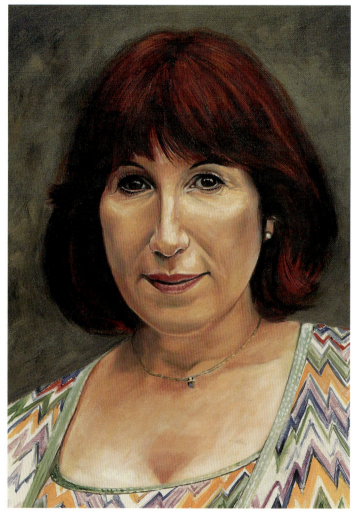

⊛ The underpainting for this oil portrait of Kay Mellor was very bold and over-emphasized her facial structure.

⊛ The finished portrait corrects that harshness and smoothes out and softens the face.

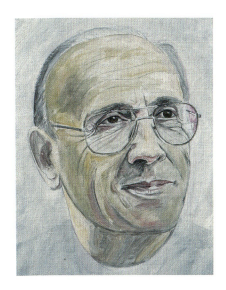

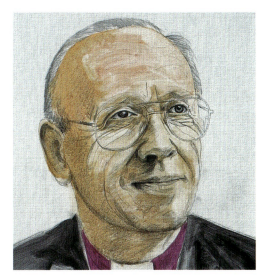

◀ The Most Reverend and Rt Hon Dr David Hope KCVO has a wonderfully expressive face, so when I was exploring his facial structure my drawings played upon the asset of his eyes and the shape of his nose. Getting the eyes correctly proportioned was important to bring out the gentle nature of the man.

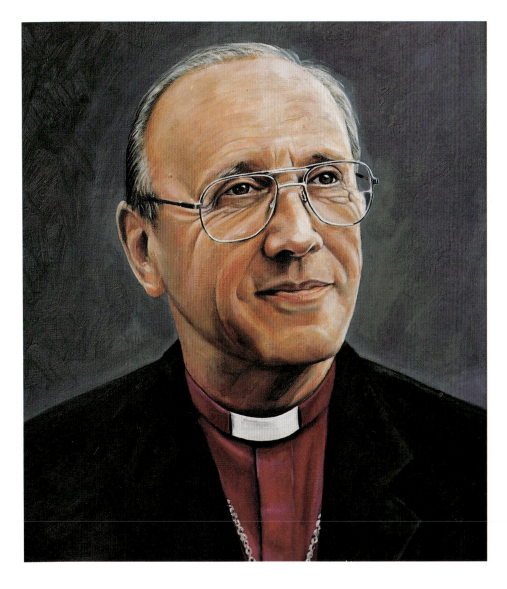

◀ The finished portrait had lots of presence, depicting a man of great warmth and strength of character. Archbishop David told me that he thought it captured his personality perfectly, which was a wonderful compliment.

Lord Healey

I really enjoyed working on Denis Healey's portrait, not only because he has such an interesting face but also because he is such a fascinating and personable man. He arrived at my studio bright and early, full of enthusiasm. I explained what I wanted to achieve in terms of a strong and solid portrait reflecting his status. "Just get the eyebrows right, lad, and you've got me!" he retorted, which set the tone for the day! Lord Healey has a powerful personality and his face reflects his strength of character. It was important for me to find

Born in 1917, Denis Healey served in the army during the Second World War before becoming the Labour MP for South-east Leeds in 1952. He has been Secretary of State for Defence, Chancellor of the Exchequer and, later, Deputy Leader of the Labour Party. In 1992 he became Baron Healey of Riddlesden.

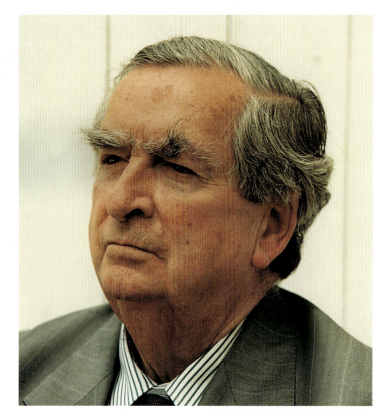

the angle that best showed off that strength. I began by making several pencil drawings from different viewpoints. When you are painting a portrait of someone with a very powerful persona it is essential to try a range of poses to find one that emphasizes the facial structure. I tried several informal poses as well as a more traditional approach.

One pose stood out from the rest; it showed him looking away into the middle distance and captured his dignity and charisma. I then had my work cut out developing the facial structure. Lord Healey was right when he said that his eyebrows dominated his features – they almost had a life of their own!

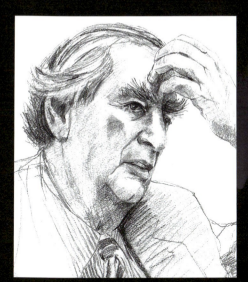

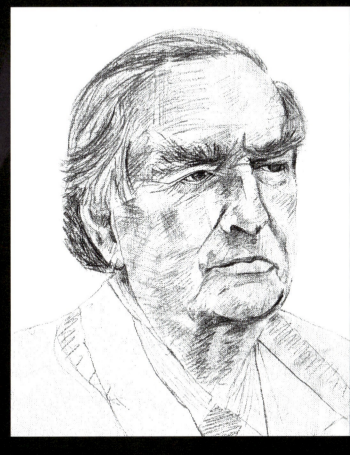

◬ When producing drawings for a portrait, try to describe different expressions if possible. Lord Healey has a very strong and quite severe expression but it did change slightly from drawing to drawing. I tried looking at his face from different angles and sides, even introducing an element of movement by drawing his hand scratching his brow.

◬ The angle I decided upon which best described his features and gave him an air of authority had his jaw set firmly and his eyes appearing thoughtful.

Starting to paint

After completing a drawing that fully analyzed Lord Healey's facial structure, I then had to begin the actual painting process. He simply had to be painted in oils; there was no alternative. Indeed, his features had to be almost sculpted in paint in order to build up the necessary solidity and strength.

I attacked the canvas by underpainting tones with large hog's hair brushes and paint straight from the tube – not thinned down by turpentine or linseed oil. This is a very important stage in the painting and one that requires some confidence in your use of paint. Always remember to follow the angles of the face as you work, even if you don't think the brush strokes themselves are going to be evident. Brush strokes applied thickly will build up the underlying structure and, as the paint dries, you will detect small areas of texture which you can enhance with glazes.

When you apply the underpainting, make sure that the main features you have drawn remain visible. It is very easy to alter the shape of the eyes, for example, by applying paint so enthusiastically that it overlaps the line. Be confident with areas of paint that show mass, such as the cheekbones and forehead, but be sensitive in areas of detail.

▼ I began building up the painting by using large, really bold brush strokes which progressively followed the planes of Lord Healey's face.

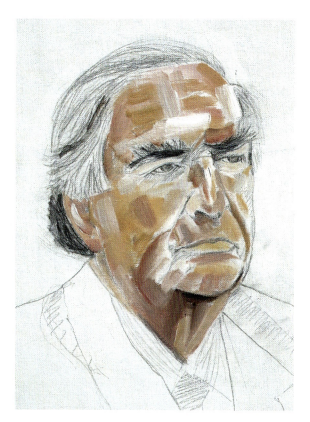
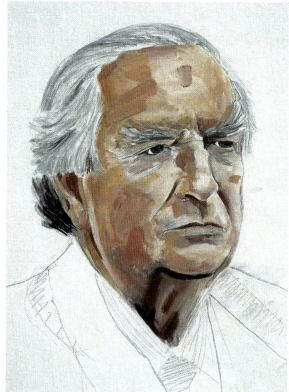

The right brushes

I always begin with a large hog's hair brush when I am laying in the main facial structure, but, as the facial detail increases, I use progressively smaller brushes until a hog's hair brush can no longer provide me with the detail I want. It is at this point that I transfer to sable brushes loaded with thinner paint. I like working with flat hog's hair brushes, sizes 12, 10, 8, 4 and 2, and sables, size 3 through to 12.

Underpainting not only gives you the form and shape of the head; it also creates energy in the paint surface which the light catches once the painting is hung on a wall.

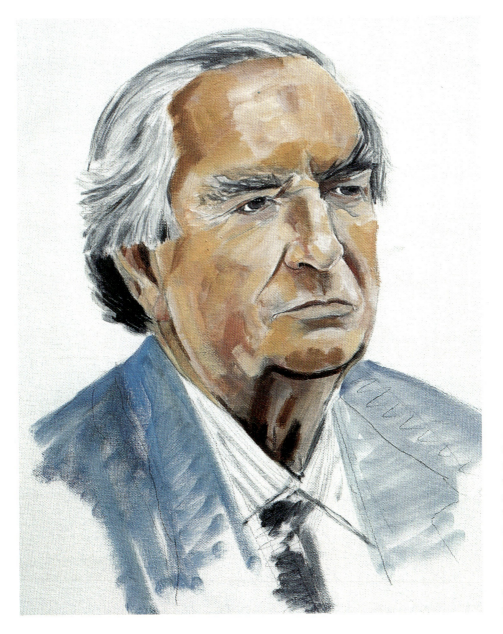

◀ I added more underpainting and the main structure began to emerge quite strongly. I still followed the angles of the face and used a hog's hair brush loaded with quite thick paint to provide extra texture to the surface of the painting.

Creating the skin tones

After developing the general structure of the face, the paint must be allowed to harden slightly before the next layer of skin tones is applied. It is then a matter of careful observation, some skilful brush strokes and a slight exaggeration in the skin tones when building up the structure.

You will notice that in this painting, which is extensively developed, the cheekbone, for example, is highlighted with lighter brushstrokes. It is only when the glaze is applied that this slight exaggeration is toned down.

The final part of my portrait of Lord Healey was to paint those magnificent eyebrows. For this, I used a fine sable brush, size 1, to get the detail right!

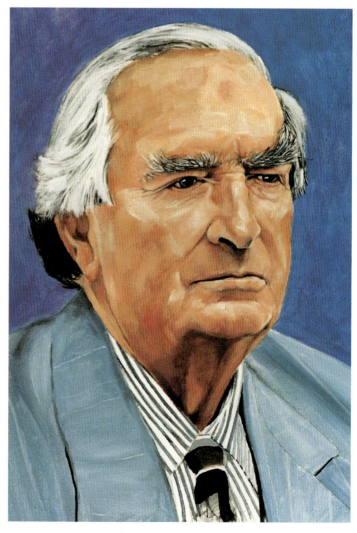

▲ You can build up the paint quite heavily as the underpainting develops. I always start putting some suggestions of colour into the background and the sitter's clothing at this stage of the painting.

▶ The underpainting for the portrait gave me all the basics in terms of the features. I then had to set to work with a fine sable brush and paint more detail in Lord Healey's hair and eyebrows.

⊕ Lord Healey is proud of his rather magnificent eyebrows! 'Just get the eyebrows right, lad!' he joked.

Alan Hydes '98

⊕ The eyes in this painting do not look towards the sitter because I wanted the mood of the portrait to be pensive. I placed small highlights in the eyes to bring them to life.

⊕ Lord Healey has a very firm set to his mouth which makes him look quite severe at times.

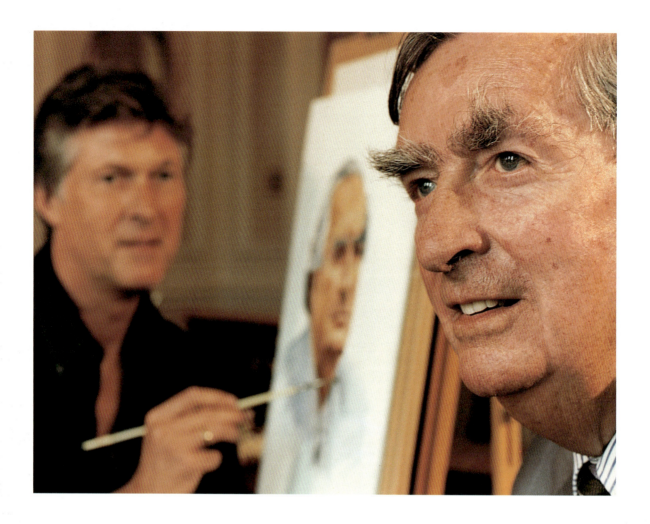

The final result

It was difficult for me to decide how to describe Lord Healey in paint because he has two quite distinct sides to his personality. He is the warmest and friendliest individual imaginable for the most part and he regaled me with stories of his wartime exploits and life as a young man. However, he is also a serious ex-politician and an intelligent, thoughtful and powerful man, so the challenge in the painting was to try to establish some middle ground. When he saw the painting he felt that it made him look a little severe but commented that it was a part of his personality. The portrait now hangs in his family home in Sussex.

⊕ The portrait session was very enjoyable as I listened to some really interesting tales from Lord Healey's days in the army and his fascinating stories about his life as Chancellor of the Exchequer.

⊙ *Lord Healey*
Oils
55 x 40 cm (22 x 16 in)
The finished portrait involved a lot of glazing and work with my sable brushes. I felt it conveyed dignity and confidence. When Sir Edward Heath saw it, he decided to have his portrait done, too.

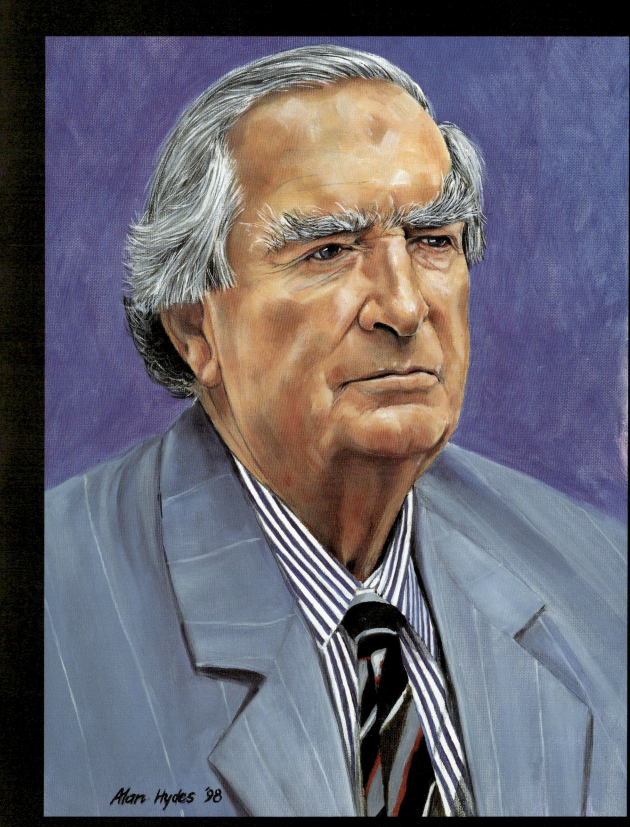

Alan Hydes '98

S | kin tones

Oil paint is wonderful for portrait painting, simply because it is so adaptable in its application. It can be used straight from the tube, thick and opaque, or you can thin it down with turpentine or linseed so that it is translucent – ideal for laying glazes over other colours. The pigments mix well without losing strength, and oil paint dries slowly, giving you time to adjust and revisit areas of the painting.

⬆ My portrait of Janet Alton, a personal friend, was produced in oils, which are perfect for developing accurate skin tones. You can lay thin glazes over the previous colours until the correct tones are achieved.

Start by underpainting

When I produce a portrait, I do it systematically, using paint to provide the structure of the face before I begin to analyze the complex skin tones. I use an underpainting white for this process and lay down the structure with a fairly wide, flat hog's hair brush. Using underpainting provides the essential solidity of the facial structure, emphasizing angles and planes with brush strokes which will be seen as an important texture in the surface of the finished painting.

I use hog's hair brushes (sizes 3 to 8) and lay on the paint quite thickly, purposely leaving the lines of the brush strokes in the paint surface. Starting with the widest brush, I paint in the main planes of the face, and the flatter areas across the forehead, cheeks and chin. I follow the angle of the planes with my brush strokes and try to be as honest as possible to what I see in front of me. It's almost like sculpting in clay to create a model of the head. The finer the angles and planes I observe, the smaller the brushes become until the structure of the head is complete. I then put the canvas to one side for at least a day to allow the paint to dry sufficiently before working over it in a range of skin tones.

Using light and shade

Obviously, there are no set rules for the way in which individual artists see colour, but for a normal Caucasian skin colour I find that a range of colours does the trick. These include Rose Madder, Transparent Gold Ochre and Naples Yellow. You can, of course, buy ready-mixed colours as flesh tints, but even with these you have to add other colours to make them look natural.

I always like to get a certain amount of contrast into a face in terms of the way I depict the light falling on the features.

◀ Richard Todd was painted in soft lighting conditions, giving me the opportunity to explore his skin tones fully. I really enjoyed producing this painting because his face offered such a wealth of subtle tints in his natural skin pigment.

As described earlier in this book, lighting is very important in portraiture as it helps to emphasize the form.

So painting a portrait with light and shaded areas requires a wide range of colours and tones to describe what you see in front of you. In my portrait of Barbara Dickson (see page 36), I took this to extremes and the colour of her skin and hair disappeared into a very dark range of tones in order to give the painting a more theatrical atmosphere.

Adding the skin tones

When the underpainting is stable, the flesh tints are applied. I begin by making a general assessment of the skin tones of the sitter. The larger areas of the cheeks and forehead are painted with quite broad brush strokes. At this stage, I half-close my eyes to simplify the amount of tonal information my retina is absorbing. Doing this restricts what you actually see and literally cuts out some of the finer tones. I find this helps me enormously when making a quick assessment of the range of tonal values in the face. I then try to describe these

tonal values in paint, using a range of colours, usually mixed with Titanium or Flake White to reduce the intensity of the raw pigment. I also allow the drawing to remain visible where possible in order to ensure that I do not lose the marks that I made indicating the facial structure.

Working on skin tones, I always over-emphasize colours and tonality in the first instance and then gradually change the colours as I progress the painting.

I always begin by laying down a general skin tone across most of the face. This is an intermediate colour that acts as a very basic tone to give me a starting point. I don't like working from a white canvas and am averse to working from an unnatural colour which is miles away from flesh tints. A mid-tone means that I can build up highlights with lighter tones, and develop the darker structural tones using deeper tints with the basic colour as a reference point.

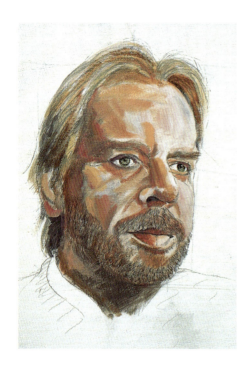

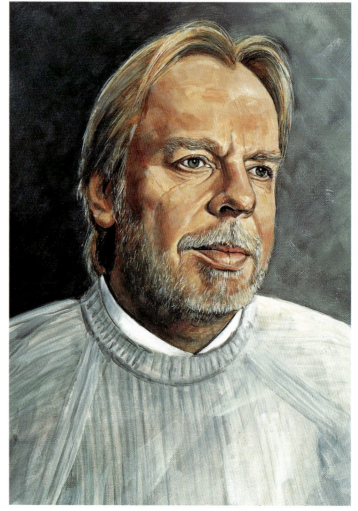

⊕ The underpainting was strong in the first instance, and I kept toning things down until I felt that the skin tone was accurate.

⊙ Musician Rick Wakeman's face had a more even skin tone than my previous sitter, Richard Todd. He was also slightly tanned and so his skin coloration had hints of Golden Ochre.

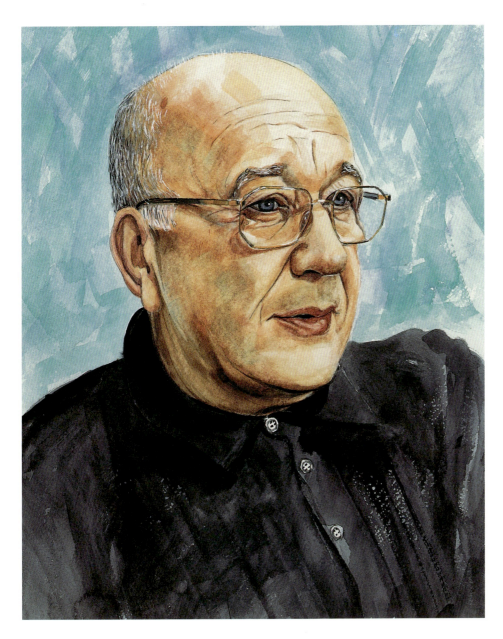

⊙ I painted actor Roy Barraclough in soft watercolour washes. Underpainting has the same effect in watercolours as it does in oils. Build up the main areas of tone in subtle washes, allow them to dry and then add the gentler skin tones and fine hair over the top of the underpainting. You might want to use an opaque designer's gouache for finer strands of hair.

As the painting takes shape, I usually add a neutral background colour which is as close as possible to the finished background tone. This helps me to see the portrait skin tones develop against what will be a permanent background tonality. It brings out the true colour in the face instead of showing it against a flat white background.

From then on, it's a case of empirical science – trial and error to find out just which colours and tones best depict the face of the sitter. Rose Madder provides a lovely warm tint, whereas Transparent Gold Ochre gives a slightly sun-kissed feel to the skin.

Lord Harewood

When I arrived at his home, Lord Harewood greeted me warmly. He was wearing the most amazing silk tie which I couldn't take my eyes off. I realized that it would probably take as long to paint as the actual portrait, and he was rather amused at the thought that he had set me an additional task which would test my mettle!

The great-grandson of Queen Victoria, Lord Harewood closely resembles his grandfather, King George V, especially in the set of the eyes and nose and the same style of beard and moustache. Due to time constraints, I could only paint a head and shoulders portrait, which was a shame because I would have loved to have produced a full-length picture with his library as a backdrop. The benefit of painting someone in their own home is that they are more relaxed in familiar surroundings. However, there are drawbacks – his lordship kept nodding off during the sitting!

Painting someone with such an unusual face is almost an adventure. Lord Harewood's features are full of character, and I had to use all my powers of observation to faithfully represent the proportions. His remarkable collection of fine art includes an imposing Epstein statue of Adam, Picassos and family portraits by Gainsborough and Reynolds.

Born in 1923, Lord Harewood is a cousin of the Queen and the grandson of George V to whom he bears a striking resemblance. His twin passions are opera – on which he's acknowledged to be an expert – and football (he is the president of Leeds United Football Club). His estate, Harewood House, is one of England's finest stately homes.

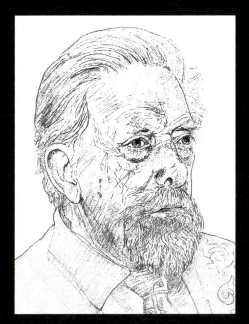

⊛ Drawing in his features with a 4B pencil, I placed the emphasis on Lord Harewood's eyes. They are always the most important part of any portrait, and I spent some time trying to capture their intelligence and thoughtfulness. The structure of the face was interesting to study, too, as the main features are very pronounced and distinctive.

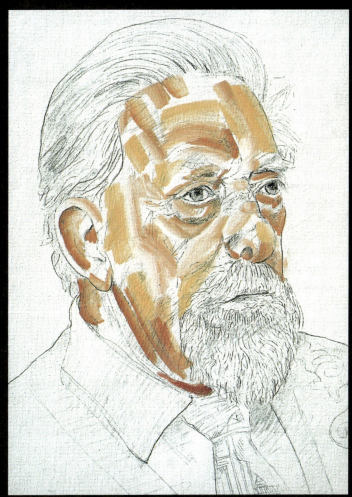

⊛ The most challenging aspect of painting Lord Harewood was building up the structure of his face. I had to draw his features accurately before applying the oil paint in layers, gently building up the texture and tonality of the skin tones. I painted the portrait from an angle to make the best use of his features in combination with the beard and moustache. The blue tints of his clothing could then be used to set off the skin tones with a soft grey-blue background complementing his silver hair.

▼ After producing a detailed drawing, I worked over it with a range of colours, including Rose Madder, Naples Yellow, Transparent Gold Ochre, Yellow Ochre and Titanium White. As the underpainting developed, the facial structure was strengthened.

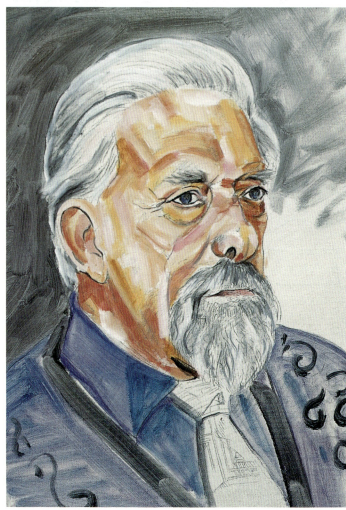

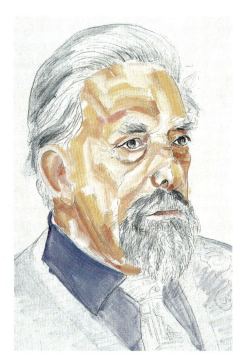

The underpainting

I began laying in some underpainting white mixed with a basic skin tone, using brush strokes that followed the angles on Lord Harewood's face. To model the features, I left the brush strokes pronounced with some hog's hair bristle in the paint.

Once the paint was drying, I applied other skin tones over the underpainting, working methodically: breaking down areas of tone and building up the colour slowly. Hints of Transparent Gold Ochre were applied to give the skin a slightly sun-tanned look. I also worked on the hair in broad brush strokes, following its flow. Initially, I painted the beard quite loosely before getting to work with my sable brushes.

I always use sables to work on the details, such as the eyes and hair, when the underpainting and skin tones are almost dry. That tie needed a lot of painstaking detail but it was a wonderful contrast to the skin tones and well worth the effort.

▲ When I reached a point where the main facial structure was complete, I used finer glazes and a size 2 sable to put in the fine hair, paint the exotic pattern on the tie and put life into the eyes.

▶ *Lord Harewood*
Oils
55 x 40 cm (22 x 16 in)
The portrait took me several weeks to produce as I spent lots of time not only on the underpainting but also on a series of glazes which were drifted over the structural brushwork. Lord Harewood has an interesting mixture of fine tints in his face which I tried to represent accurately.

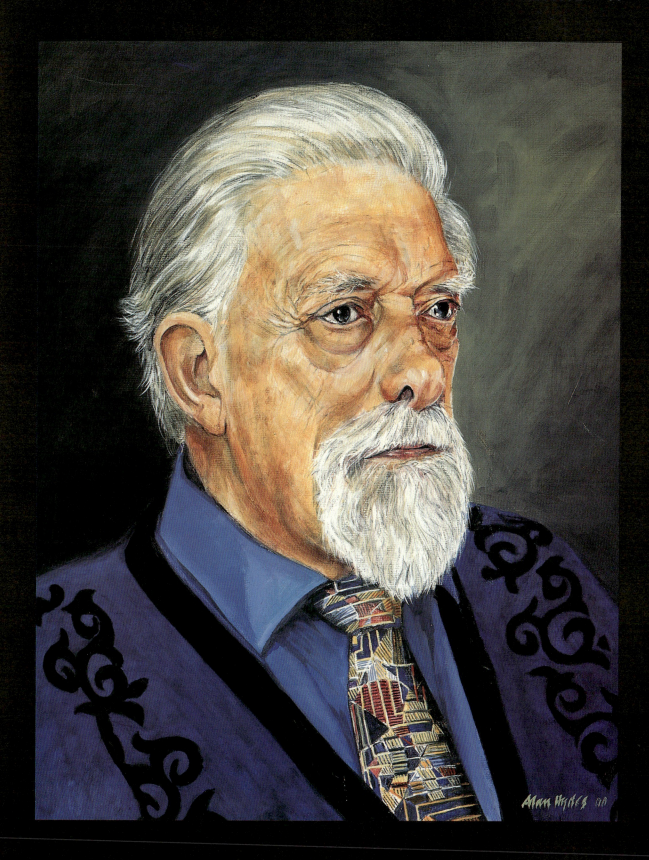

Creating personality

The all-important element in any portrait is capturing the character and personality of the sitter as you perceive it. It is, however, one of the most difficult things to achieve. After all, a person's personality is not a tangible thing that can be measured and carefully depicted in a drawing or painting. If it were that simple we wouldn't struggle with portraits to get a meaningful image of the person sitting in front of us.

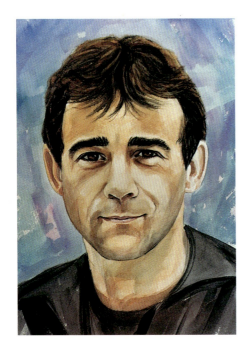

Ⓐ Pencil drawings from all sides of Michael's face soon gave me what I needed in terms of best representing his personality. I put very little detail into the drawings, but once I began to work with watercolours I found the best angle was head on. His eyes dominated the portrait.

Michael Le Vell

Portraits are a record of what you think you see in a person when looking at them. I try to absorb as much information about a sitter as I possibly can. I look at the way they think and act, their emotional state and their attitude to others. I can then get a feel for their character and personality to put into the painting. I look for visual clues in their face that best illustrate my personal feelings about them. These might be laughter lines or just a twinkle in their eyes.

In real life, Michael is similar to the character he plays in *Coronation Street*. He is energetic and affable with a lively mind. He was interested in what I was doing as I tried to capture his character on paper, constantly asking me questions. I drew him from different angles, working quickly with a 4B pencil without spending too much time on detail; it was the essence of the man I wanted to put across. His eyes tended to dominate all my drawings, mainly because of their size and colour and his long dark eyelashes.

Creating personality in this watercolour portrait was a matter of trial and error, doing one drawing after another until I felt I had captured him. I found that a head-on portrait would best describe his character – a full-face angle with his eyes looking directly outwards. It showed off his expressive, large eyebrows and good facial structure and allowed the observer to come into full contact with his eyes. Because he has a fairly light skin tone, his brown eyes have more impact.

The final watercolour wash drawing was simplistic and very uncomplicated – but it represented my perception of Michael perfectly. He appears down-to-earth with some awareness of his celebrity status, but he also looks inquisitive and interested in what's going on around him.

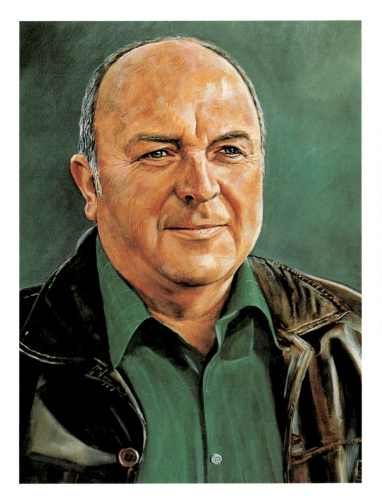

◉ I really could not fail to get personality into this portrait, because Phil is such a character. I added my own perception, too, which gave the portrait quite a dynamic presence.

Phil Alton

Phil Alton is a self-made Yorkshire businessman who has built up a company from scratch to make it one of the most profitable businesses of its kind in the United Kingdom. He has worked hard all his life, raised three sons with his lovely wife Janet and is rightly proud of his achievements. When he contacted me, he was unsure about the way I might depict him. As I got to know him, I became very aware that he was a man of integrity and pride with a phenomenal work ethic.

Creating a portrait not only depends on what you see in your sitter's face but also on what they are wearing. I wanted to show Phil's individuality and a conventional business suit would have made him look too conformist, so I asked him to wear a casual jacket. He chose a leather blouson which, together with an open-necked shirt, created a casual, relaxed pose. It was obvious from his face that he was an achiever, a man with lots of presence and a twinkle in his eye that betrays his keen sense of fun.

Chris Chittell

Chris Chittell plays a man with a nasty streak in his role as Eric Pollard in the network TV series *Emmerdale*. However, his television persona is totally the opposite of the man in real life so when I painted his portrait it was a case of finding his true personality and putting aside completely his TV character. Chris has an interesting, well-proportioned face and quite striking eyes. He keeps himself very fit (mostly by running marathons for charity) and, as a consequence, there is little fat on the man. His face is lean and well boned and it is also very expressive.

I drew Chris from various angles before painting the watercolour portrait and purposely chose watercolours to produce these drawings because they allowed me to analyze quickly the colour of his eyes and to put in his skin and hair tones. I wanted to make Chris look thoughtful and also to reflect the strength of his personality. I made the image have direct eye contact with the observer which helped to make his character seem more assertive.

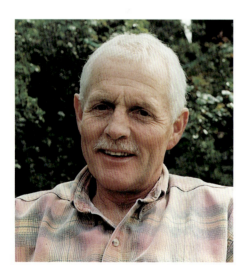

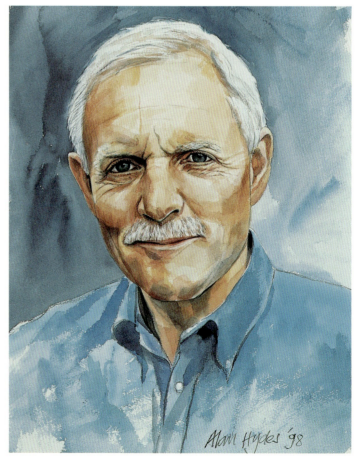

⊕ Chris Chittell is known to millions as Eric Pollard on the long-running TV soap *Emmerdale*.

⊕ The watercolour drawing was painted on 638 gsm (300 lb) paper with a medium-textured surface. I used light washes over a pencil sketch which had been fixed for about 30 minutes before I began to apply pigments.

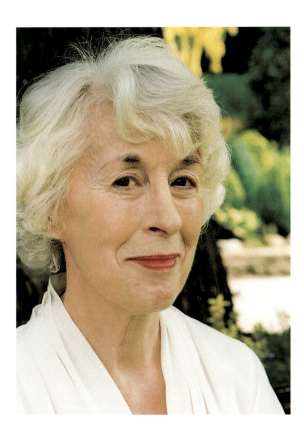 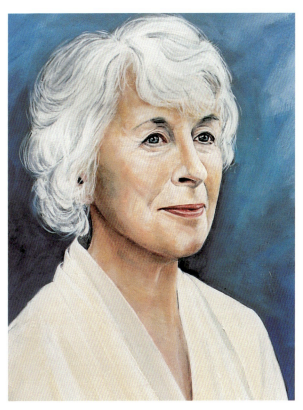

Alice McCreery

In this portrait, the eyes bring out Alice's personality whilst the composition and pose provide some serenity. Naturally ebullient and cheerful, Alice is also contemplative and sensitive, and I wanted to portray this in the portrait.

I worked for a long time on the eyes to bring the portrait to life. I concentrated on the heavy eyelids and tried to get depth into the eyes. I decided that the face should be turned away so the viewer could observe Alice without making eye contact. The simple forms of the blouse and the subdued colouring overall were easy on the eye, reducing distractions. Alice's half smile also made the painting easier to read.

Alice is a friend and I knew instinctively how I wanted to portray her personality. There are no hard and fast rules about how to do this; whether you use certain lines, tones or colours depends on the way in which you perceive your sitter. Often the face will betray their character by the way life has etched in the clues. Someone who smiles a lot usually has distinct laughter lines, whereas a person who worries will develop a frown. The best way to bring out personality is to concentrate very hard on the eyes. They are not known as 'the windows to the soul' for nothing!

◉ Alice dressed in a very simple top for the portrait to avoid any distractions with pattern and colour.

◉ The portrait produced in oils was very subdued in colour, which allowed Alice's personality to emerge against a plain background. I didn't want to include anything fussy which would take the eye of the observer away from Alice's eyes in the portrait.

Jilly Cooper

As I turned into the driveway of Jilly Cooper's old chantry in Gloucestershire, I was feeling a little nervous at the thought of painting her portrait. Jilly is a good friend; she had already bought some of my botanical paintings, but to add a portrait to her collection was a little daunting. Painting someone you know can be more difficult than painting a stranger. What if she didn't like the finished painting?

I wanted to paint Jilly in her living room, surrounded by her large collection of paintings, including a large full-length Bratby portrait of her in her twenties. I decided to create a head-and-shoulders portrait which would capture her character in fairly loose brush strokes. I wanted to portray her wicked sense of humour and warmth. A formal, classical portrait would not illustrate her essential character.

I began by sketching her from various angles. Her hair constantly fell over her eyes, slightly masking her face, and she swept it back with her hand as she chatted. This was pertinent to my image of Jilly as she has always seemed shy in a way, not really relishing her fame and celebrity status. Being peered at in an analytical way by an artist who was painting a portrait for posterity was obviously a little nervewracking. The fact that her hair gave her some cover would be an important element in the final portrait.

Born in Essex, Jilly began her career as a cub reporter on the *Middlesex Independent*. She worked as a puppy fat model and switchboard wrecker before writing a regular column in *The Sunday Times*. She has sold 11,000,000 copies of her 37 books. She is married to Leo, a publisher, and lives in Gloucestershire with an assortment of animals.

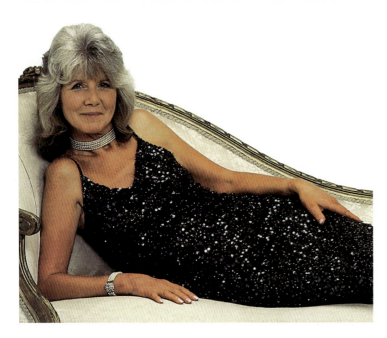

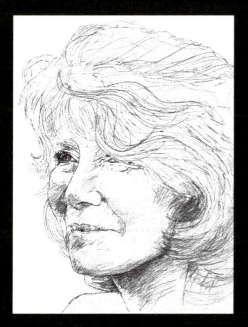

△ I used a 4B pencil and sketched quite freely. The outline drawing allowed me to position Jilly's face in a way that emphasized her quite delicate features. The hair falling over her left eye helped to bring out her character.

△ Jilly's features are small and pretty, and her eyes are very expressive and full of fun. Her mouth has a pleasant shape and is always smiling, so I had the main elements of the portrait set in my mind before I began to draw. I didn't want to portray her head-on because I wanted the trademark thick blonde hair to be an important element in the painting.

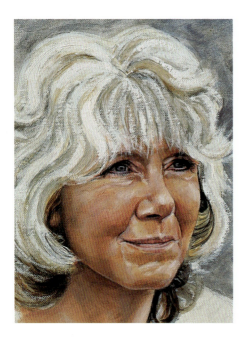

⊗ I did this colour sketch earlier but it was too formal and failed to capture Jilly's personality.

Capturing Jilly's personality

I tried a few sketches and an oil sketch of Jilly looking to the left but felt it was too head-on. I sketched her from the other side, letting her hair fall partly across her eye. This worked well and I decided upon that pose. The challenge was to bring her eyes to life and capture her lips in a typical half smile.

To bring out your sitter's personality, try to identify a physical mannerism or characteristic and use it. Jilly's hair is her trademark – it has been in much the same style for many years. The slight smile on her lips also seemed to say a lot about her personality. If someone is naturally vibrant and positive, let it come out in the painting. It's the same with the twinkle in someone's eyes – capture it if you possibly can!

Combine all these elements and avoid distractions, such as patterned clothes or fussy jewellery. I kept Jilly's portrait simple – the only detail was in the face and hair. Everything else was left to the imagination: no detailed background to distract the eye from the face and the simplest of clothes. I gradated the background almost down to a dark Payne's Grey to give it depth and to contrast with Jilly's blonde hair.

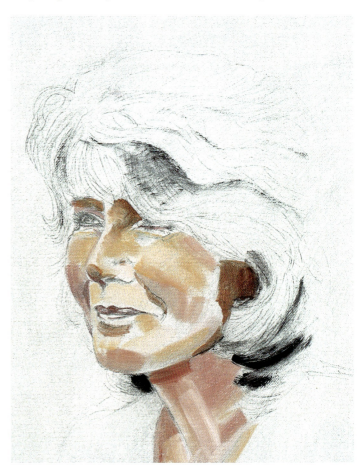

⊗ I began gently adding colour to the drawing on the canvas board. This painting had to remain quite simple and not be overworked.

Underpainting Jilly's face

The painting developed quite quickly and spontaneously, even though I was using oils. Having outlined Jilly's features, I used a hog's hair brush to lay in some colour which would form a basis to work from in terms of constructing the skin tones. I used a flesh tint made up of Rose Madder and Naples Yellow. The paint was mixed with underpainting white and I worked quickly with fluent strokes of colour following the planes of her face. I also laid some Titanium White and underpainting white into the hair to give it substance and shape. I then took a smaller hog's hair brush and worked on the narrower angles of the face.

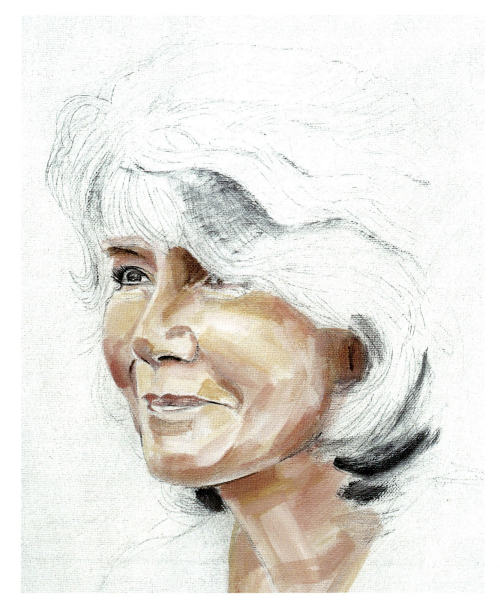

◉ As I worked on the portrait, I began to put detail into the eyes and the hair, and then introduced a background tone to help me to accurately capture the tonality of the skin.

Painting Jilly's eyes

While the underpainting was drying, I worked on the eyes, analyzing their colour and shape. I decided that they were the most important element of the painting and I had to capture their vibrancy and sparkle. To paint them, I used a sable brush and paint thinned with distilled English turpentine.

It was then a matter of studying Jilly's face and making decisions on how to describe what I saw. The important thing was to allow the image to emerge naturally from the canvas. I took a split second to glance back and forth rapidly from my canvas to the sitter. This helped me observe accurately the way in which light plays on the skin tones.

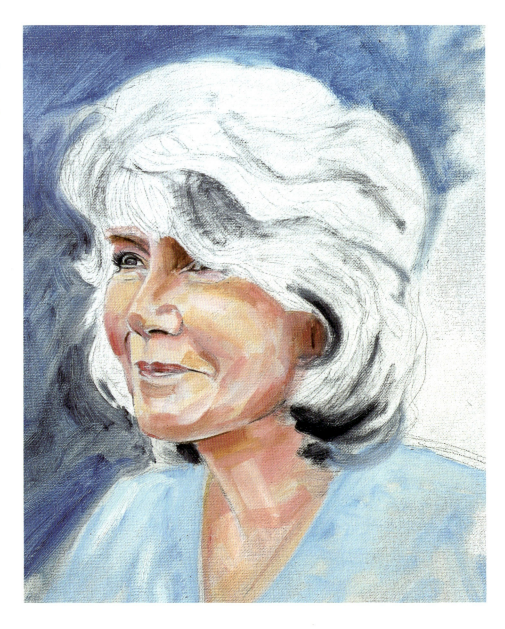

▶ As the painting emerged, I used thicker paint following the planes of Jilly's cheeks, nose and chin. The paint sculpted the main features in a general way.

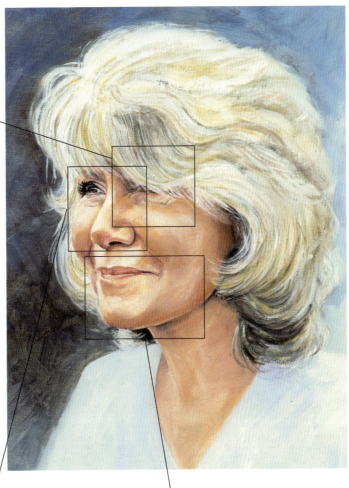

Jilly's hair is almost her trademark. It is very thick and long and appears to have a strong, natural wave. She tends to hide behind it on occasions and I thought that the portrait should feature it strongly, partly covering one eye.

As with any portrait, the eyes are so important when creating personality and presence. In this portrait, the eyes are full of life and fun.

I had to capture that half smile which Jilly often has. It is a charming smile and conveys part of her vibrant personality.

The finished portrait

The finished image was left almost like a big detailed sketch in oils. I deliberately painted it very loosely and I think it describes Jilly's mood on the day the portrait was painted. Sometimes a portrait is much more powerful as an image when it is very simple without too much detail. I kept the detail to a minimum because I thought the painting should be more of an impression rather than a careful study of Jilly's face. When you're in her company, she is very animated and enthusiastic, so you don't really sit and study her face. It would have been incongruous therefore to have made my portrait anything other than a fleeting moment in time.

⊕ Jilly and I spent a lot of time together sitting in her garden, just talking about life in the art world and, of course, her great interest in botany.

⊕ *Jilly Cooper*
Oils
55 x 40 cm (22 x 16 in)
The finished painting is a mixture of keen observation and paint, used to create a mood. Jilly wore a simple woollen jumper in a soft colour which certainly enhanced the whole feeling of the painting in terms of its tonality.

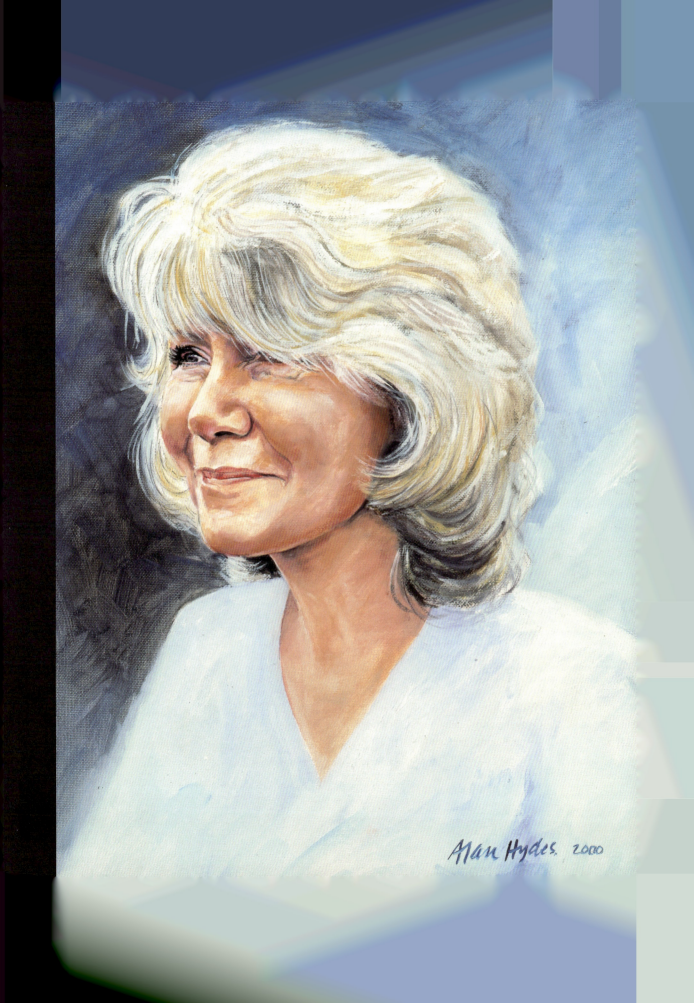

Alan Hydes. 2000

Portraits in settings

Putting your sitter into a specific environment obviously does more than just illustrate the world around them. The background you choose to use can bring in many other aesthetic elements which help to create a visually interesting painting. The setting can also introduce different textures, shapes, colours, tones and angles which create important dynamics within the finished painting.

◉ Introducing the strong symbols relating to Bishop David formed an important part of the composition. His crozier and silver cross had a personal significance but they were also the symbols of his office as Bishop of Ripon.

Creating dynamics

I always try to create diagonals in the image to lead the viewer's eye into the main subject – the sitter's face. Horizontal and vertical lines create order and tranquillity, but diagonals bring energy into a composition that the eye recognizes and follows. Curvy, swirling shapes also create dynamics that provide visual stimulation. Try to identify different elements in the imagery around the sitter when you are painting a portrait and utilize the natural phenomena of dynamics. If you can tie in elements in the background that say something about the sitter, then you have a perfect opportunity to maximize all the natural dynamics of the setting in your finished painting.

It is always good to receive a portrait commission that involves more than just a head and shoulders depiction. Painting faces is very challenging in itself, but working on a large portrait which involves not only a full-length study but also an interesting setting is even more fulfilling. Back in the seventeenth century when portrait painters, such as Van Dyck, were commissioned to produce large portraits, the purpose of the painting was to represent the sitter in all their glory, showing their wealth and status. A man or woman posing for their portrait would wear their finest clothes and be positioned against a background that clearly illustrated their personal taste and breeding.

These days, artists paint portraits of people in an environment that sheds further light on their personality and interests. When I am called upon to paint people of very special status, such as the Bishop of Ripon (opposite), I try to incorporate something within the painting that illustrates their interests outside their occupation.

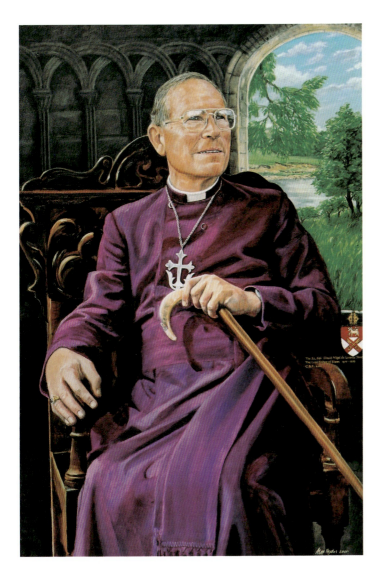

◀ I included a view of the River Wharfe which runs beside the Priory at Bolton Abbey as well as some ruined architecture to provide a natural setting for the portrait. This created not only an ecclesiastical feel, but also a feeling of history and strength.

Bishop David Young

When Bishop David Young told me he loved walking in the Yorkshire Dales, particularly around Bolton Abbey, I decided to include this landscape in the background of his portrait. I wanted a simple backdrop, almost like a theatrical set, to provide a glimpse of something he loved. The greens in the landscape also helped set off his magenta robes.

I wanted to portray Bishop Young in a dignified pose but in a relaxed, informal way. I liked the idea of an old, solid wooden chair with its carved patterns as a symbolic image of timeless stability. The curvilinear shapes to the right of Bishop Young's shoulder gave the portrait a decorative element without detracting too much from his face. His crozier, made from wood and horn, was a perfect device to lead the eye in a diagonal to his face.

Robert Fleming

An interesting painting to work on was the portrait of Robert Fleming, who, having spent 11 years in the Royal Air Force as a medic, vowed he would learn to fly. Later, as a successful businessman, he got his pilot's licence and set about achieving his ultimate aspiration – to fly a Spitfire. He not only bought a Spitfire Mark XI but also a Hurricane and a Messerschmitt!

He told me about his interest in aircraft while we were discussing his portrait commission, and we arranged to drive down to Breighton airfield in Yorkshire to see the aeroplanes at first hand. They were phenomenally impressive machines, and I could see instantly their magnetic appeal. Within an hour, I had planned out the portrait in my mind. I would incorporate both the Spitfire and the Hurricane into the setting to create a unique image.

Creating the landscape

The way in which I painted the landscape would create an impression of elevation, looking across the plane, so that the Hurricane, with Robert sitting on the wing in a Royal Air Force flying suit, would be imposing. Having taken some reference photos, I began drawing a rough composition, trying to achieve a balance between the three elements – the actual portrait of Robert Fleming himself, the aircraft and the Yorkshire landscape. It was important that I identified the

▽ I incorporated the distinctive landmark of Almscliffe Crag, which is near Harrogate, into the background of the painting to make it an obviously Yorkshire landscape.

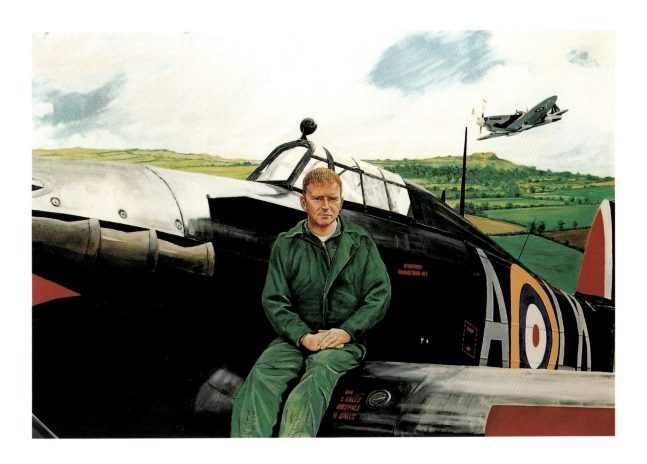

landscape quite specifically as Yorkshire because Robert is a Yorkshireman through and through, so I wanted something that would be immediately recognizable as a Yorkshire landmark. Earlier in the year I had been working on a large painting of Almscliffe Cragg near Harrogate and the image of the rocky outcrop was in my mind, so I tried it out behind the aircraft and it fitted perfectly into the composition.

The scale of the painting was very important so I sketched out various large images on sheets of paper sellotaped together before I decided on the final dimensions: 117 x 150 cm (47 x 60 in). What followed was a lot of hard work drawing the Hurricane, Spitfire and landscape. To give a real sense of scale, I needed the Hurricane to be imposing but not to overwhelm the figure of Robert sitting on the wing. I also wanted the angles of the aircraft structure to create some dynamism. So I made the Spitfire's wings angle towards his head, and the Hurricane's fuselage lead the eye to his face.

During the sittings, Robert gave me invaluable information about the aircraft which helped me to paint the textures and colours. The red strip on the wing, for example, is canvas for the aircraft's guns to fire through.

▲ The result was a really colourful, atmospheric painting, portraying Robert Fleming in a relaxed and contented pose against one of the most unusual settings imaginable!

Robert Palmer

My painting of international rock star Robert Palmer, famous for his groundbreaking video and number one hit *Addicted to Love*, was interesting to paint. It featured on his *Honey* album and ended up being printed on the actual disc.

I discussed the album with Robert and he played me some tracks. The painting became a sort of collaboration, as we pushed ideas around and discussed the lyrics. As the final painting would be seen small scale (CD size) I had to make the imagery visible on that scale, even though I would paint it on a canvas 37.5 cm (15 in) square. I depicted Robert from an unusual angle, looking down from above his head. In this way, the imagery of the lyrics could rotate around him like a massive halo of colour and form. It was to be a surreal portrait which portrayed what was going on inside his head.

Planning the portrait

I began by photographing Robert from above, exploring different angles and shapes to gather enough information to produce some rough designs. I had a series of photographs, lyrics, tapes and notes on the way Robert wanted the portrait to look in terms of atmosphere. I played the tracks from the album as I worked. Deciding on what imagery to use to illustrate the lyrics was a bit like selecting pictures from a dream as the songs conjured up their own images.

▶ The initial drawings to provide Robert with an idea as to how I wanted to illustrate the lyrics to his songs was drawn in coloured pencils. It showed how the imagery would flow around his portrait and provide a visual frame of colour.

Working up the background images

I showed Robert the colour roughs with their images of a leaping dolphin, Venetian masks, sailing ships and compass, a honey bee and an oak tree. They all swirled around the main portrait as the sky featured the passing of a day from sunrise to sunset. Robert loved it.

It took months to produce the portrait. The background was as important as the portrayal of Robert. I painted in oils on canvas to give myself plenty of latitude for the complex imagery. The result was another quite unique portrait which would be seen by literally millions of people around the world who purchased Robert's new CD.

ⓐ The oil painting was quite surreal with different symbolic images conveying my interpretation of Robert's lyrics. He wanted Eros to feature strongly.

The fisherman

One great thing about portraits is that they provide a lasting image of a person for centuries after their death. Following generations can look at the painting and get a feel for what their ancestor was like as an individual. So it is always a good feeling to be able to provide a family with a portrait of a loved one, as I know it will be treasured and provide the family with pleasure over successive generations.

Painting from photographs

I am often asked to paint a portrait from photos of someone who has died, but I don't like working purely from photographs as it is difficult to get a feel for a person. The range of images is often quite limited: either too formal and 'posed' or too informal and of poor quality. If I don't have the visual information from which to work, I cannot take the commission.

However, if a wide range of photographs is available and I can get a feel of the individual from them, I can create a portrait with a good likeness. One example of this is the portrait I produced of John Trickett. He was only 57 when he died and his family wanted to remember him in a special way by commissioning a portrait. When his daughter Annette contacted me, I explained that I could not paint him unless I had a series of photographs that brought out his personality. She sent me snaps of her father in all kinds of situations, portraying the kind of man he was. I talked to her about John and what he was like as a man. I learnt he was a keen fisherman and always said that when his time was up, he would like to leave this world doing something he loved – fishing.

So the portrait was pretty much fixed in my mind from that point on. I decided to depict John on his fishing boat, rod in hand, enjoying himself. Luckily for me, one of the photographs showed him doing just that. So the trick now was to get the scale of the painting right with the image of the boat sitting well on the canvas area.

I produced several big drawings before deciding on the final composition. I wanted the angles in the boat's structure to lead the viewer's eye to John's face and the way he sat to convey a relaxed, happy mood. It was important to keep the background simple so as not to detract from John himself. I therefore made the elements

④ I painted the sea in a way that gave the impression of water but was in no way a realistic representation. I just used flowing lines of colour to add an interesting texture without them distracting from the portrait.

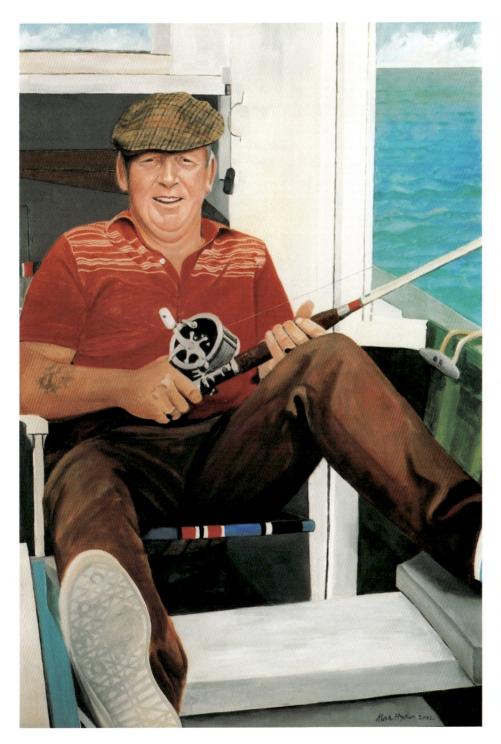

⬆ I put little detail into the fishing reel because it provided good pattern qualities. I deliberately kept it simple as anything that is too complicated and mechanical can detract from the face of the sitter.

◀ The setting to this portrait gave the image of John a lift in terms of the tonality. More importantly, it portrayed him in the way he would have liked to be remembered, and the way in which his family will always think of him.

of the boat as basic as possible. Even the sea and sky were kept really simple, giving an indication of a pleasant afternoon without looking too realistic. I used subdued neutral colours in the background whilst keeping the brushwork gentle and unobtrusive.

I nformal portraits

Many famous historical portraits are very formal and imposing. They were painted to make the sitter look important, dressed in fine clothes and surrounded by the trappings of wealth. Most informal portraits were self-portraits, painted by artists as examples of their skills to gain further commissions. But more latterly it has been quite acceptable for top professional painters to produce very informal portraits.

ⓐ This was Robert's school photograph, showing him in a shirt and tie which he did not like wearing as he was always a free spirit as a child.

Creating a relaxed mood

Impressionists, such as Monet, loved to paint informal portraits at the seaside or in gardens, especially during the hot Mediterranean summers. Picasso later followed their example, and today artists such as David Hockney tend to lean towards informal portraiture in a big way.

I enjoy working with my sitters on informal studies. The triptych I painted of the Blackburn family (see page 49) was very informal. It had an air of relaxation and contentment about it. I used dappled sunlight on the sitters to create an even more atmospheric effect, and I sat Louise in a big cane chair which gave the painting a very informal feel. I painted her, sunk low in the chair, looking happy and relaxed.

One informal portrait I really enjoyed painting was the one of my son Robert when he was seven. He was wearing some smart clothes to go and visit his grandmother and I suddenly realized he looked quite adult dressed that way. The formal jacket and sweatshirt were a far cry from his usual attire of a T-shirt and shorts or jeans so I reached for the camera and took a couple of photographs. They ended up pinned on my studio wall and I suppose it was inevitable that one day I would be inspired to paint a portrait from one of them. So I simply dashed off a quick little painting in oils. The background to the original photograph had been the back garden to my house but when I had completed the oil sketch of Robert's face and jacket I decided to put a seascape behind him. It ended up looking like the Caribbean, so all in all the painting became quite surrealistic – Robert in a wool Burberry sports coat standing in front of the Caribbean!

However, that is the joy of informal portraits; you can do them as you wish and have great fun painting them. I like to

◉ This little portrait of my son Robert was painted quickly on a very small scale. The setting was surreal as I substituted the Caribbean shoreline for an English garden!

mix the imagery to produce something with an interesting visual impact, and just changing something as simple as the background can make an enormous difference. But often it is the way in which you pose your sitter that will give the final picture a marvellously informal feel.

The O'Leary family

While I have been writing this book, I have been working on a large family portrait for the football manager David O'Leary. When David commissioned the portrait, he wanted his family to look relaxed and informal as opposed to a carefully posed painting. Therefore he decided to wear an open-necked shirt, daughter Ciara wore a ribbed sweater and son John chose a plain white T-shirt. Even the jewellery was simple and not ostentatious. Ciara chose to wear a cross on a chain around her neck. The colours, too, were subtle – just subdued tones with no garish tints – so when I introduced the skin tones there was a real warmth to the flesh colours. The family had recently been abroad on holiday and their gentle sun tans added to the overall effect of warmth.

Because the portrait will eventually feature four individual studies of David, his wife Joy and their two children, I decided to make each member of the family have eye contact with

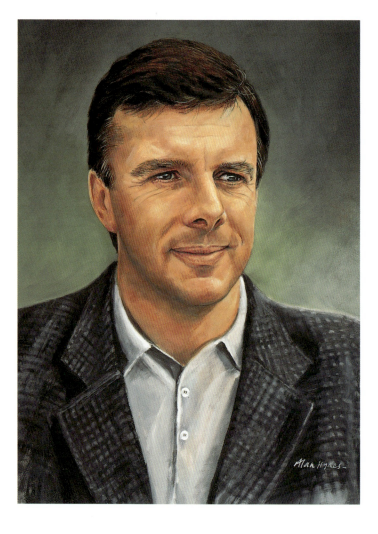

◉ This portrait of David O'Leary which I had previously painted is more formal than the image I produced for the family portrait. In this painting, he is posed in a traditional way, wearing a sports jacket, and looking like a top football manager.

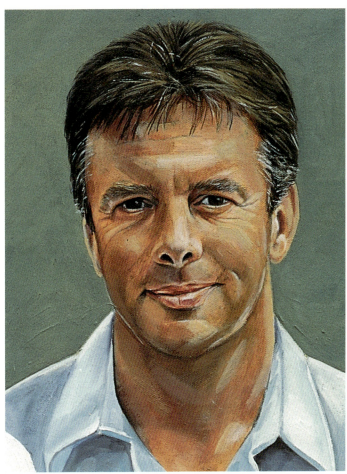

⊕ The individual portraits have quite a lot of detail but are all lit from the same light source. The studies are a close analysis of each sitter in every way.

the observer. This will have the effect of allowing anyone looking at the portrait to look at each face individually.

For the backdrop to the painting I won't be using a Yorkshire scene or any figurative imagery. Instead, there will be a gradated backdrop of colour which will complement the skin tones and make each face stand out from the canvas, giving the whole portrait more depth. Rembrandt was a master of this technique of creating mood and atmosphere with nothing but pure colour which is applied in a very loose way.

Working in watercolour

When I painted a portrait of Ralph McCreery, I began with an idea in my mind that I wanted the picture to be quite light in feel and depicting him relaxing in a comfortable chair. So I set off with my cameras to his house to take a series of photographs that would show him as I know him to be – an easy-going and thoughtful man with contentment written all over his face.

Take some photographs

If you want to produce an informal portrait there are two ways in which you can go about it. You can either work directly from your sitter in a pleasant and comfortable environment or you can arm yourself with photographs of the sitter and try out several poses which you think best describe his or her personality. It is not until you get the film processed and the pictures printed that you can

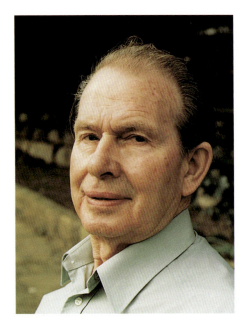

⊛ Ralph wanted the painting to be very informal, so he chose to wear a casual open-necked shirt.

⊛ I worked on a large sheet of watercolour paper with a rough surface and produced a pencil drawing of Ralph, looking relaxed, sitting in his favourite antique chair.

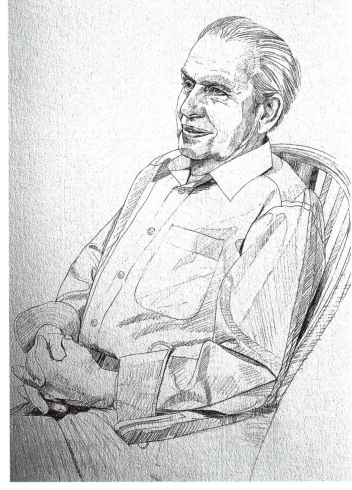

be sure that you have what you want. It is often a look in the eyes of your sitter that can make one frame stand out from the rest.

I took two rolls of film when I visited Ralph McCreery and we used two different locations in his garden. From the prints, I found that I had three real alternatives to choose from but I still could not make up my mind which one to use, so I showed them all to both Ralph and his wife Alice. Collectively we chose an image which we all agreed was the one that really represented Ralph at his best and expressed his individual character.

So having sketched the main image of Ralph to try out the pose on paper, I then enlarged the photograph in order to be able to see all the detail. This is a very important thing to do as some people often attempt to work from extremely small photos and end up getting things badly wrong simply because they cannot actually see the detail.

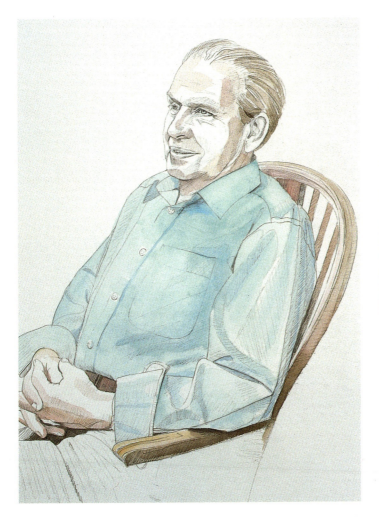

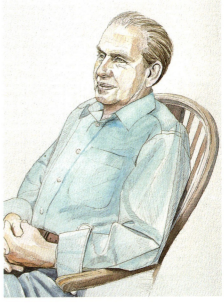

◀ I built up the watercolour washes gradually, enabling the painting to develop slowly. I used a size 7 sable brush with a fine point. This is a large brush, holding a lot of pigment at one time.

▲ I introduced some fine watercolour washes in order to indicate Ralph's skin tone and to provide some awareness of the light source, thereby giving his features some form.

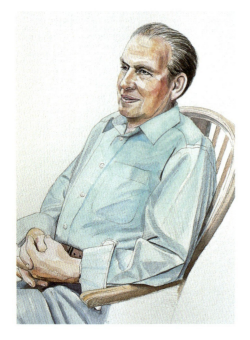

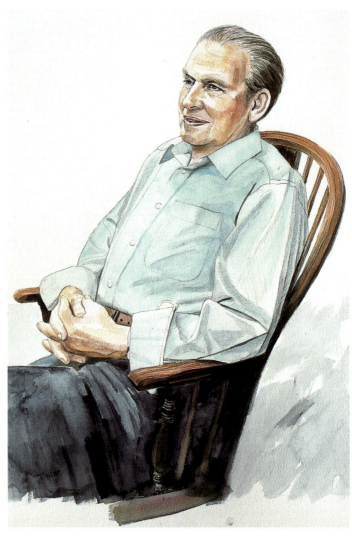

⊛ As the painting developed, I applied some heavier tone and then concentrated on the skin coloration against the colour of Ralph's shirt. It was important at this stage to work the painting up as a whole so that the tonality could emerge in a balanced way.

⊛ I introduced weight at the bottom of the painting by putting lots of colour into Ralph's trousers and the chair, which helped to give the portrait solidity.

Working in watercolours

I began my portrait by producing a large line drawing with minimal detail, adding some tone to the drawing to give depth to Ralph's features. If you want to produce an informal portrait in pencil and wash, don't forget to choose a decent watercolour paper to work on. Even if I think I might only use a pencil for a portrait, I often select a good watercolour paper in case the drawing demands wash tones at a later stage.

On this occasion I had set out with the intention of producing a loose drawing with watercolour washes and I had chosen an expensive heavyweight watercolour paper with a beautifully textured surface. Having worked up the drawing I began to work in wash. The colours I chose to begin the wash work were quite pale and muted as I wanted to build up the colour gently as the painting progressed.

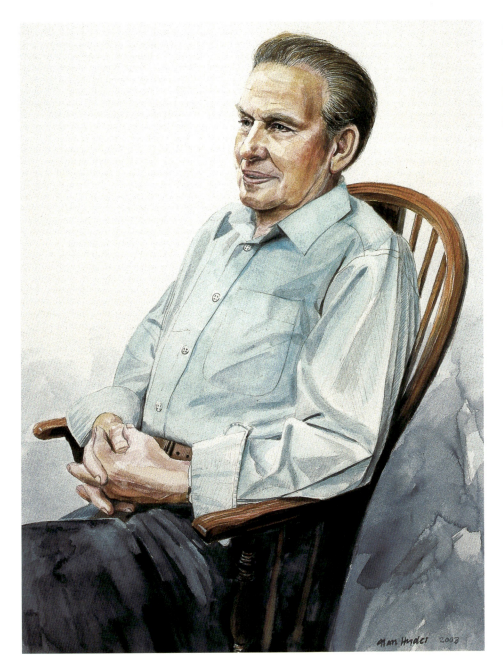

◀ The final painting had lots of detail yet it still had a soft watercolour feel. If it had been a little more in profile it could have been Whistler's father!

Using a size 7 sable, I laid the colour on in big areas of wash, making sure that I didn't overlap the boundary of the drawing. Because I had fixed the drawn image with fixative spray I was confident that the drawing would remain in place throughout the colour application. It was then a matter of working up the colour, stage by stage, taking care to let each layer dry off before I added more washes over the top. Finally, I added a wash of Payne's Grey behind the chair to balance the composition and provide more weight at the bottom.

S elf-portraits

Self-portraiture is a strange in-turned art. Painting an image of how we see ourselves and as we imagine others see us is a very difficult task. Over the centuries, artists have undertaken this and left us with a unique record of themselves, and it is wonderful and exciting for us today to view painters such as Raphael, Rembrandt and Picasso, pictured as they saw themselves in their youth and old age.

Ⓐ This photograph was taken specially against a white background to focus on the form and colour of my face.

Using photography

We are very fortunate to be able to see images of ourselves as other people see us. Video and photography give us an instant image of how we look today, whereas in the past painters had only their reflection in a mirror to work from which, in turn, left us with that mirror image as the finished portrait. These days we can paint a portrait that shows our features as others see them.

So where do we begin when painting a self-portrait? Well, we can either set up an easel in front of a large mirror and then draw what we see, or we can look to photography to provide us with a starting point. For the purpose of this book, I decided on the latter.

I began by deciding what I wanted from a self-portrait. As I was writing a book on portraiture, I felt I had to produce an image to help explain how I built up the features in a face, so rather than paint a full-length portrait I chose to concentrate purely on the facial features. I did not want to include any form of background and so the photographs that were taken for me to work from were shot against a plain white canvas.

From a roll of 36 exposures, I then chose a few images which I felt would translate well into drawings. You have to consider what it is you want in terms of a final image and this involves the way you see yourself as opposed to the way you want other people to see you. I did not want a portrait with a grin on its face like a holiday photograph; I wanted something that represented my features simply as a record of what I look like at this stage in my life.

The images I chose were close-ups of my head from different angles. I began by making a series of drawings from the photographs before deciding on the main portrait.

Drawing my features

I concentrated on my main features without any real intention of getting character into the studies. The drawings were an exploration of the facial structure but, at the same time, I tried to establish a suitable angle which best described my face. The drawings were worked up in pencil using a 2B for an initial outline, and then I developed the tonal areas with 5B and 6B grades.

When drawing my features, I used a modulated line to draw details such as my eyes, mouth and hair. I then applied tone in a way that described the angles of my face. I shaded in areas following the natural plane of my forehead, cheeks and chin. I also took away some tone to highlight areas such as the cheekbones and forehead. This was achieved by using a kneaded putty eraser on its side. When I took tone out of areas of my hair, I shaped the eraser into a point and removed thin areas of tone following the natural flow of the hair. I also lifted some areas of tone from the eyes to give the impression of light reflecting off the pupils.

▼ When I began planning the self-portrait, I had a series of photographs of me taken from different angles as reference. I worked from these photographs using pencil and tried out several angles before deciding on a view looking head on.

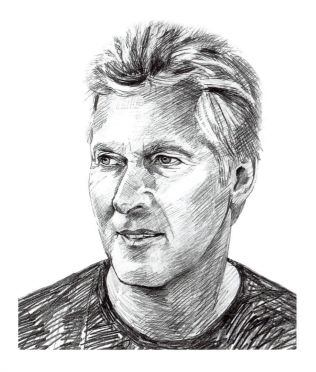

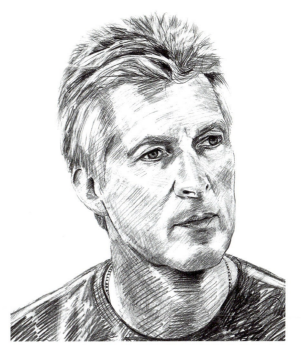

Planning the portrait

After completing several sketches from the photographs, I decided on the best angle for the finished self-portrait. Rather than creating a painting in oils, I chose to produce the final painting in watercolours.

The original sketches were drawn on heavy cartridge paper with a smooth surface, allowing the latitude to produce plenty of detail. However, I now chose a heavy 638 gsm (300 lb) watercolour paper with a rough texture to work on.

After producing a relatively detailed drawing on the watercolour paper, I then fixed it using a standard fixative spray to ensure that the drawing would not smudge when water was applied to the paper.

◉ I produced a head-on drawing which was the angle I thought would be suitable, but I felt that the expression was wrong and so I chose a more serious picture to work from for the main portrait.

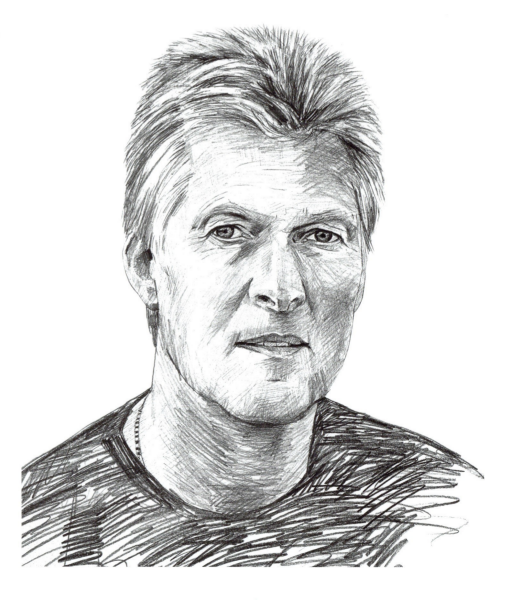

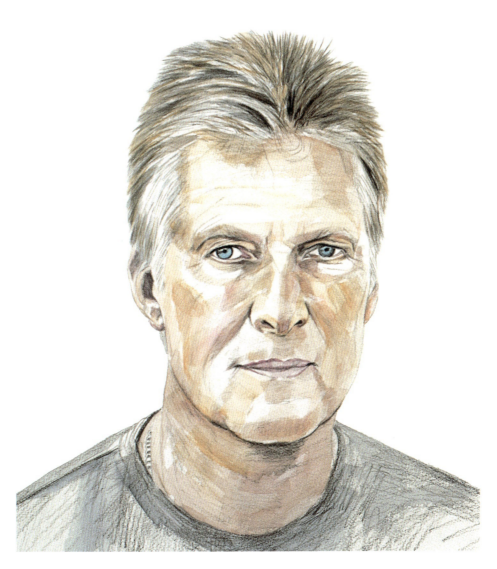

◉ I began applying the watercolour gently, observing the main areas of tone which helped to give form to the face. I painted in the T-shirt and put more tone into the hair. I also introduced colour into the eyes and balanced the overall tonality by drifting in slightly stronger colour.

Starting to paint

I painted the skin tones, using the lighter tones to begin with, developing the tonalities as the painting progressed. I wanted the painting to be fairly loose and painterly and began by using a size 7 sable brush, laying the washes on with some freedom. I also added some granulation medium to the paint to give it a broken texture.

The colours I used were selected for their warmth and resemblance to my own skin tones. As I spend quite a lot of time outdoors and abroad, my skin tones are usually dark so I had to take this into consideration without making the actual tones too deep in my palette. As the painting progressed, I introduced other colours to indicate such things as the blue tint in my eyes and the colour of my hair.

◉ When working on a watercolour portrait, I build the colours up like sheets of glass, one over the other, gradually increasing the overall colour until I feel that I have achieved the correct balance. I then use a size 1 or 2 sable brush and put in the detail, such as the hair strands, the eyebrows and anything that requires some clarity. I also use designer's gouache to pick out elements I want to be more opaque.

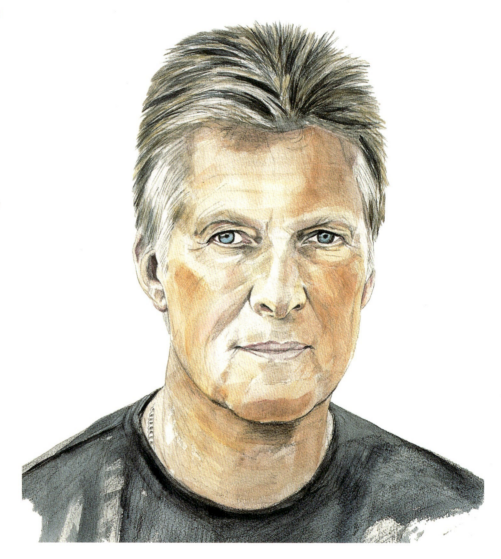

Using the right techniques and brushes

When painting in watercolours, you must allow washes almost to dry off before applying the next wash if you want the colour to remain fresh-looking. This allows the white of the paper to show through the washes, giving the painting vibrancy and clarity. When you are producing a painting in this way, do not overwork it! It's easy to spoil a lively painting by using too much colour, making it look flat and muddy.

The most important thing is to be confident in the way you apply colour. Use a range of brushes of different sizes and shapes. I use flat sables for the work on angles in the face, and sable brushes for details, such as eyes. When you produce your own individual portrait, try experimenting with different brushes and find out what suits you.

◉ *Alan Hydes*
Oils
55 x 40 cm (22 x 16 in)
The final portrait represented my features but I felt that it made me look too serious and a little sad so the next self portrait will definitely be from life looking through a mirror – if I can ever face painting another one.

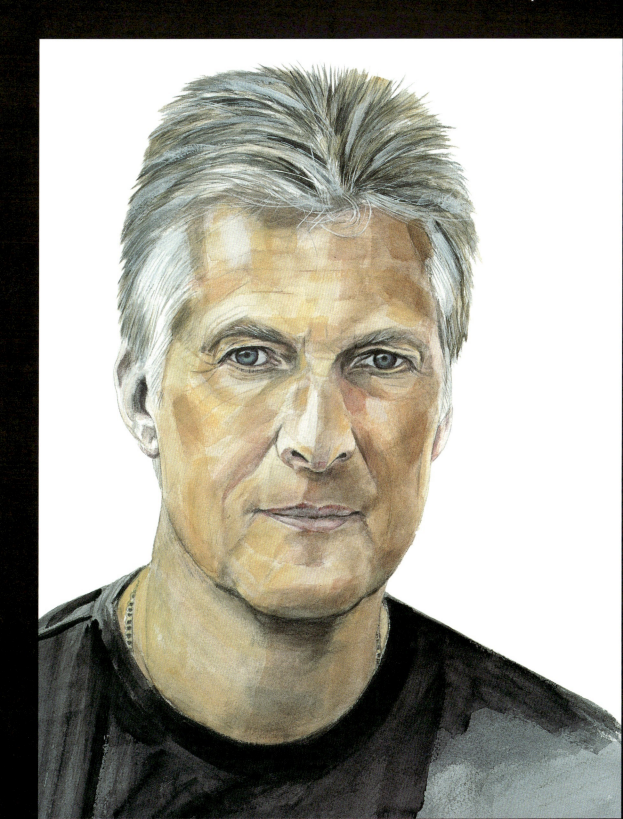

M ounting and framing

When a portrait is complete, you will have to present it in the most effective way possible. Choosing the right frame can really enhance a portrait but, equally, selecting the wrong frame can have an adverse effect, overpowering an image and not showing off the painting to its best advantage. Therefore mounting and framing your work is something that you have to consider very carefully.

Ⓐ Richard Whiteley samples a frame which is rather unusual in design. It certainly sets off his striped blazer and brightly coloured tie!

Choosing the right frame

It is essential that you frame a portrait in a sympathetic way. A Van Dyck portrait which was painted in 1630, for example, would look totally incongruous in a modern bright silver frame, just in the same way that a modern portrait would look quite wrong in an old-fashioned elaborate frame.

You have to ensure that whatever frame you choose balances the painted image in terms of the weight and thickness of the mounting. It is easy to overpower a fine and sensitive drawing by imposing a very large frame around it. Equally, if you have a strong and deeply coloured complex painting you will reduce its presence if you place a small, thin, insignificant frame around it.

It is well worth taking a trip to your local art gallery or even the National Portrait Gallery in London in order to look at the way in which some of the nation's most important portraits have been framed. Notice how some are in elaborate gold and silver frames whereas others have simple wooden ones.

Over the centuries, the craft of picture framing has changed a lot. In the late nineteenth century, for example, the Pointillists actually incorporated the frame into the painting, and painters such as Seurat and Signac continued the painting onto the frame itself. So the painting was framed in a wooden frame and the artist worked onto the wooden frame in oil paint using dots of vibrant colour.

Other important painters, such as Monet, made sure that their frames would be quite large and imposing because their pictures were highly colourful and often much larger than the norm. However, Monet also hung some of his very large canvases with no frame at all because he felt that the paintings did not require framing.

◁ I use a wide range of frames for my portraits. The portrait with the Hurricane is framed in aircraft metal whereas my other portraits and landscapes are set in hand-made frames, usually with 24-carat gold leaf.

Mounting your pictures

It is not just the frame that matters; it is the way in which you mount the image in the first instance. Acrylics and watercolours can be mounted using fine mounting boards to set off the image in the frame. So, again, you have to choose carefully the colour and width of the mount. Mounting boards come in lots of different colours, textures and thicknesses, but for images such as portraits, try to select mounting card which is neutral in colour. Oil paintings are not normally framed under glass, so any mounts have to be carefully considered – you can't use an ordinary mounting board. It has to be made from a material that can be cleaned and will not discolour over time. Large frames look good on portraits when you don't use a mount.

General tips

1 Modern, simple images look best in modern, simple frames. More complex, traditional portraits work well in larger mouldings, with gold leaf and fine proportions.
2 The colour of the frame and mounting must be in harmony with the colour and tones of the painting. Avoid using new colours in the frame as this could distract from the painting.
3 Take an imaginative approach to mounting and framing, as it will enhance your work, but never allow the frame to dominate the painting or distract from it.

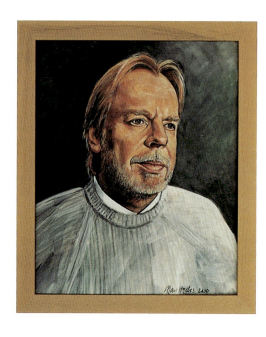

Which frame?

When I framed this portrait of Rick Wakeman I used a 24-carat gold leaf frame which was specially made by a craftsman framer. The portrait was enhanced by the frame I chose, but take a look at other possible ways to frame what is in effect a very simple and informal portrait.

◉ The frame used here is far too lightweight for the image. The portrait has a lot of visual weight and mass, with much of the canvas occupied by Rick's head, so placing a thin frame around it does not set it off in any way. This frame sits up against the painting tightly with the effect that the image is not presented to the viewer sympathetically.

▼ This frame looks much better because it is a traditional gold frame, with some weight and style. But, again, it has no fillet to help present the portrait with some room to breathe.

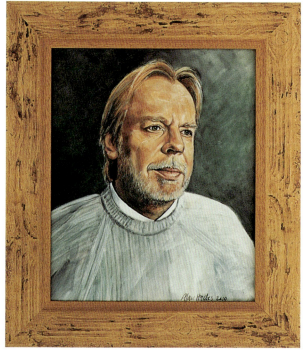

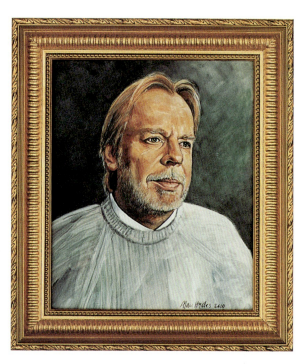

▲ This frame is slightly better because it is wider and it balances the image. However, the texture of the wood is more suited to a landscape or an abstract and is too harsh for this painting. The frame sits up against the portrait with no fillet to space it from the canvas; this does not help visually.

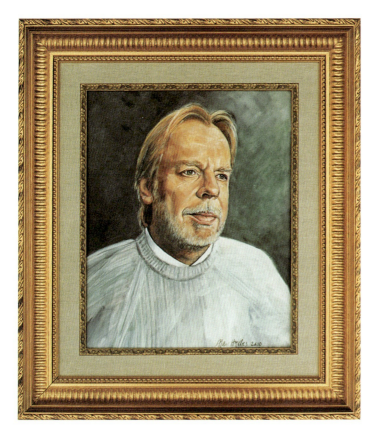

⊙ The gold frame complete with a fillet and mount looks much more impressive, and it gives the portrait the look of an important painting. Time has been spent considering the proportions and the frame balances the weight of the painting.

⊙ This is my favourite frame as it is simple yet impressive in its design. It is a hand-made frame with 24-carat gold leaf surface. You can actually see the individual sheets of gold leaf as they have been laid onto the wooden frame. It has a gold leaf fillet too which makes the whole frame look wider and more in keeping with the portrait. Frames like this don't come cheap, however!

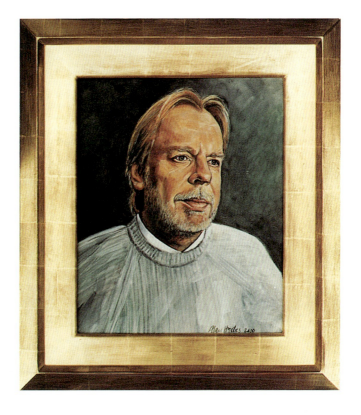

What to do if...

Mistakes can happen and things may go wrong when you least expect them to, and if you are painting a portrait there is a lot of hard work which can easily be spoilt if you don't know how to correct even the smallest problem. Over the years I have had to deal with a variety of errors and accidents while working in a range of different media. However, most accidents involving paint are recoverable if you know how to deal with them.

... you drip paint onto a finished area of the painting

This is one of the most common mistakes that you can make. Dripping paint onto a painting can really spoil a specific area. With watercolour, there is a fairly simple solution if you act quickly. Take a large sable brush, dip it into the water and strip the water from the brush by pulling it through your finger and thumb. Then apply the brush to the area where the drip has occurred. The sable will draw out the colour and remove it from the paper surface. If it fails to take away all the colour on the first attempt, wet the area with water and repeat the procedure. Only the most invasive colours will fail to respond to this technique. If you drip oil colour onto a painting, it can be removed fairly easily if the painted areas are wet. Use the same procedure as for a watercolour but substitute turpentine for the water.

... your canvas gets dinted or goes slack

Take a jar of water and a large brush and wet the back of the canvas thoroughly and then let it dry naturally. Don't put it near a heat source to dry quickly as it needs time to dry slowly for best effect. You can, of course, use little wooden wedges in the corners of your stretchers if you have them.

... you are left with lots of oil paint on your palette and the portrait is unfinished

Oil paint is a valuable commodity, and quite often when painting a large complex portrait you might have a huge volume of paint on your palette at the end of the sitting. So rather than waste it, keep the paint moist by sealing it from the air. I sometimes cover my palette in clingfilm which ensures that the moisture is retained. This will provide you with workable paint several days later. It also has the advantage of allowing you to save mixed flesh colours to ensure that they match the painting when you resume.

... there's something wrong with your drawing and you don't know what it is

If you are working on a painting or drawing and you feel that there is something wrong with the proportions but you cannot put your finger on what it is, try this very simple technique. Look at the reflection of your work in a large mirror. For some strange reason, the faults always appear to be very obvious. It could be that long periods concentrating on one piece of work create a sort of visual mind block and the mirror technique simply lets you see your work from a fresh perspective.

... you find enlarging images quite difficult

Some people find that working from photographs is very difficult because of the act of copying an image from a small scale onto a large canvas. So, if that is a problem for you, simply draw one section of the image at a time and not the whole picture. To do this, just divide your photograph into small regular squares by ruling a thin pencil line on the surface of the picture to form a grid. Then divide your canvas up into the exact number of squares on your photograph by enlarging them proportionally. All you have to do then is to analyze carefully the simple shapes in the squares on the photograph and repeat these shapes on the corresponding squares of the canvas. Within no time at all you will have a full image in exactly the correct proportions.

... you dint a wooden frame

Often a small dint in a wooden frame can be repaired simply by causing the wood to swell slightly, which takes it back to shape. The way to do this is to take a small damp rag and place it over the dint. Over a period of time the moisture will enter the wood and it will expand the grain. If you are careful and check the frame regularly, a small dint often springs back. You must not soak the frame as this will distort it.

... you damage a gold leaf effect frame

You can now buy liquid gold leaf in various colours: Classic Gold, Florentine Gold and Antique Gold. If you cannot get an exact match you can mix the golds together to get a perfect match. Before you paint the gold onto the frame, paint some on a piece of wood and let it dry. Colours quite often change quite a lot when dry, so don't spoil your frame by painting directly on to it. Be sure to get the colour match right first.

Index